IMAGE
of Ame

CANTON'S
WEST LAWN CEMETERY

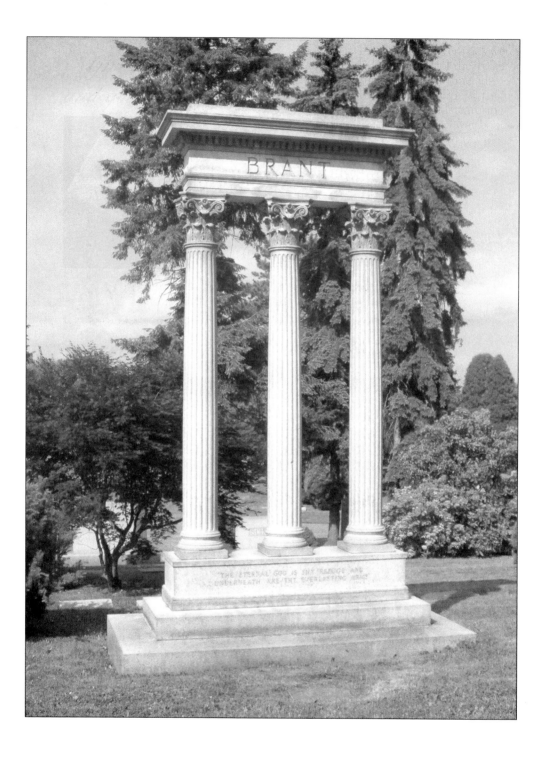

IMAGES
of America

CANTON'S
WEST LAWN CEMETERY

Kimberly A. Kenney

ARCADIA

Published by Arcadia Publishing
Charleston SC, Chicago IL, Portsmouth NH, San Francisco CA

Printed in Great Britain

Library of Congress Catalog Card Number: 2004107611

For all general information contact Arcadia Publishing at:
Telephone 843-853-2070
Fax 843-853-0044
E-mail sales@arcadiapublishing.com
For customer service and orders:
Toll-Free 1-888-313-2665

Visit us on the internet at http://www.arcadiapublishing.com

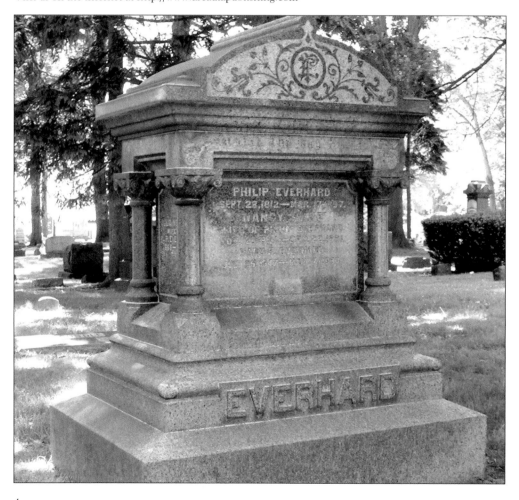

CONTENTS

ACKNOWLEDGMENTS

Canton's West Lawn Cemetery would not have been possible without the book of cemetery inscriptions compiled by the Stark County Chapter of the Ohio Genealogical Society in 1986. Volunteers spent hours painstakingly recording the names, dates, and locations of every person buried in West Lawn Cemetery to that date. Their work made mine much easier. Every effort has been made to include as many people as possible, within the limited confines of this book. There are certainly hundreds of others who deserved to be included. I would like to thank my sister Kristen Beach and my husband Christopher Kenney for helping me locate and photograph all of the gravestones in this book and for their love and support! I would also like to thank Ann Haines of the Hoover Historical Center, as well as Glenn Greenamyer, Mr. and Mrs. Robert Mann, and Barbara Hoskins, who contributed photographs to this project. All of the other historical images in this book are from the collection of the Stark County Historical Society, who owns and operates the Wm. McKinley Presidential Library and Museum. Special thanks to George Deal, the Canton Cemetery Association, and the staff of West Lawn Cemetery, who take pride in maintaining the extensive grounds to the highest standards, despite the challenges Mother Nature throws at them. Finally, this book is dedicated to all of the families whose loved ones are laid to rest in West Lawn Cemetery. It is my hope that some of their memories will be brought to life in the following pages.

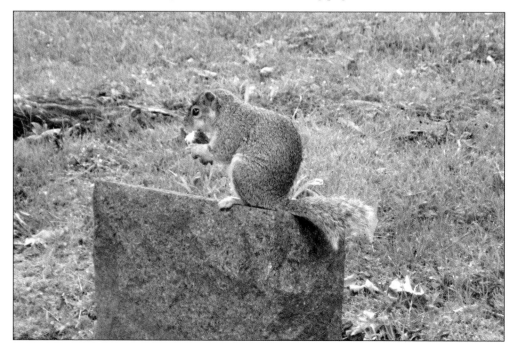

INTRODUCTION

What is it about cemeteries that capture our imaginations?

Is it the peaceful calm where everything is still, except for squirrels and chipmunks scurrying about? Is it the awe-inspiring architecture, expressing the uniqueness of the individuals buried there? Is it a morbid fascination with death?

Or is it simply the primary connection to the past, knowing that historical figures who shaped our community are right where we are standing? Names like Aultman, Hoover, and McKinley are suddenly brought to life when you stand in front of their stones, trying to figure out who married whom and how old they all were when they died.

Wandering through West Lawn Cemetery is like reading a Who's Who list of Canton's movers and shakers. The well-known names are nestled between people time has forgotten. Some stones are elaborately carved, with beautiful sculptures watching over the dead. Others are plain, with only a few words, or even just initials. Some simply say "Mother" or "Baby." On some, the writing can no longer be distinguished.

West Lawn itself is divided into two separate worlds—the present and the past. The gravestones in the old section, where so many of Canton's founders are buried, are worn with age. Some have succumbed to the test of time. Others, to the hands of vandals. The most striking difference in this section is the lack of floral tributes. Those who came to honor the dead have long since joined them, leaving no one to plant a flower or light a candle.

The new sections are vibrant still, full of beautiful plantings and newly turned earth, reminding us all how short life really is. The carvings are crisper, the dates more recent. Loved ones still visit these graves, shed a tear, recall fond memories. It is here that the past meets the present.

But one thing both sections have in common is a sense of history. The people who are buried in West Lawn are not just names and a series of dates. They once lived vibrant lives, just like you and me. They were full of energy, hope, and promise. They started businesses, founded clubs, built homes. They went to school, got married, celebrated holidays. Perhaps the phrase inscribed on the back of Anthony and Joan Rinaldi's gravestone says it best:

"As you are now,
So once were we.
As we are now,
So shall you be."

One
EARLY WEST LAWN SCENES

On March 19, 1859, 48 of Canton's leading citizens, many of whom are now buried in West Lawn Cemetery, gathered at the Courthouse Office Building near Public Square to form the Canton Cemetery Association. Each member pledged $50 toward purchasing land to establish a cemetery. Peter P. Trump and John F. Raynolds doubled their pledge, giving the group a grand total of $2400. The cemetery was originally called the Canton Cemetery, but its name was changed to West Lawn when it was incorporated in 1861.

The original "Rules Concerning Visitors" included some quaint nods to the past:

No horse . . . to be left unfastened and without a keeper.
All persons . . . to be prohibited from discharging firearms in the cemetery.
No vehicles . . . to be driven . . . at a gait faster than a walk.
No person . . . to be admitted on horseback or with a dog.

West Lawn's first interment took place on January 1, 1861 when two-year-old Ada B. Wright, who had died of diphtheria, was laid to rest. Over the years the cemetery acquired more adjoining land, doubling its size in 1880 with the purchase of "20 acres more or less" from Mr. Adam Phillips for $4,750.

The old Plum Street Cemetery, designated as a burial place by Canton's founder Bezaleel Wells, was rapidly becoming too small for the growing city. Originally located on the outskirts of town, where modern day McKinley Park now stands at 6th Street and McKinley Avenue SW (formerly known as Plum Street), the cemetery was being hemmed in on all sides by development. The Canton Cemetery Association sought to remedy this problem by starting a new cemetery.

During the last years of the 19th century, many of the graves were moved from the Plum Street Cemetery or were buried beneath "336 loads of earth carried in on wagons by park workers," according to a report by the City Board of Commissioners. The changeover was complete by 1897. Some of the gravestones that predate the founding of West Lawn may have been moved from the Plum Street Cemetery. Others were re-interred from small family plots at pioneer homesteads or churchyard cemeteries.

West Lawn Cemetery is owned and operated by the Canton Cemetery Association, as it has always been. The Association is a non-sectarian, non-profit organization that owns, manages, and maintains both West Lawn Cemetery and North Lawn Cemetery through a volunteer board of trustees and a paid staff.

West Lawn is comprised of 67 acres, with tens of thousands of grave sites. Contrary to popular belief, West Lawn is still an active cemetery with plenty of room left to grow. In 2003, the Canton Cemetery Association announced plans to offer free burial plots at West Lawn to firefighters, paramedics, police officers, deputies, and other public servants. There is space for approximately 350 people in the designated area along 4th Street NW near Lawn Avenue. Veterans are also eligible for a free plot at both West Lawn and North Lawn.

In recent years, the entire community has been outraged by the senseless vandalism at West Lawn. It is certainly tragic to see a monument that was supposed to be an everlasting memorial toppled over and broken to pieces. The employees are to be commended for their hard work restoring the stones and cleaning up the grounds after such incidents occur. Recently a new fence was installed around the entire perimeter

of the cemetery to better secure the grounds.

Cemeteries have always been a place of reverence for the living. As the following scenes show, cemeteries were also once a place of recreation where families spent idle Sunday afternoons.

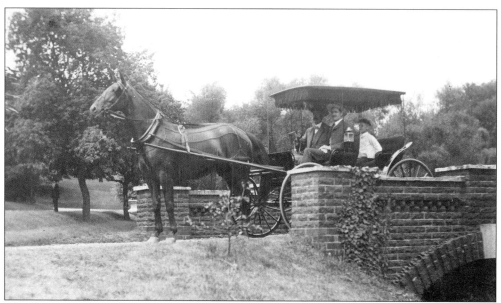

Charles, Martin, and Jay Weaver ride in a surrey at West Lawn, *c.* 1900.

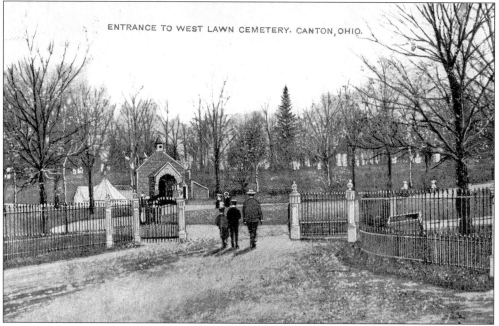

This postcard shows well-dressed visitors coming through the entrance of the cemetery. In the 19th and early 20th centuries, cemeteries were a popular place to picnic or spend a Sunday afternoon strolling.

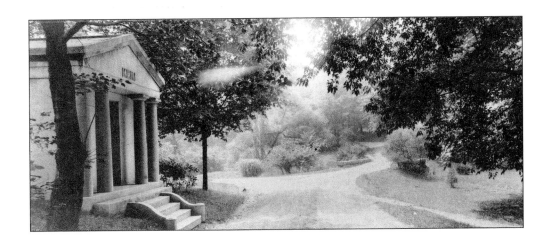

These photographs, taken in 1917, show some of West Lawn's most spectacular mausoleums. All of the mausoleums, with the exception of the Timken family whose imposing structure is situated among the trees in West Lawn's northeast corner, overlook the peaceful creek that runs through the cemetery grounds.

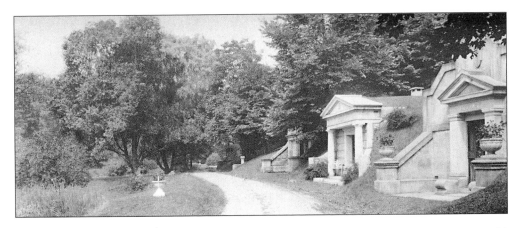

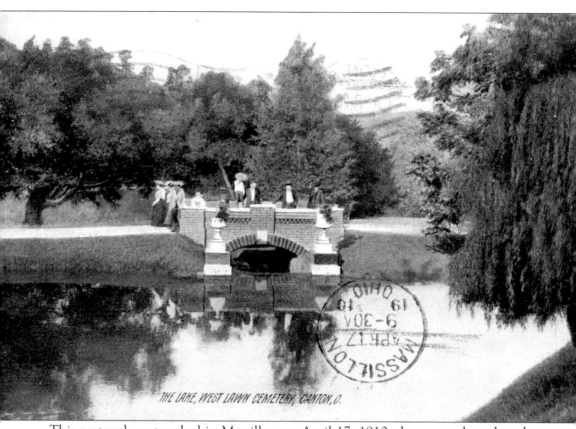

THE LAKE, WEST LAWN CEMETERY, CANTON, O.

This postcard, postmarked in Massillon on April 17, 1910, shows people gathered at "The Lake" at West Lawn. (Postcard courtesy of Barbara Hoskins.)

Two
INDUSTRIAL MAGNATES

Canton has been home to some of the largest manufacturing enterprises in the United States, earning national attention as a center for commerce. The names of the founders are familiar to many, but few know the histories of the industrial giants who emerged in the 19th and 20th centuries.

Although some of the enterprising individuals were native Cantonians, many were enticed to move their successful businesses to town by Canton's Board of Trade. In those days, Canton was an attractive place to relocate. With its proximity to larger cities and its own expanding population, it was an ideal spot for many of the industries that flourished here.

Some of the memorials to these families reflect the wealth they acquired during life. Others are deceptively simple.

A spectacular waterfall under the footbridge highlights the creek that winds its way across West Lawn.

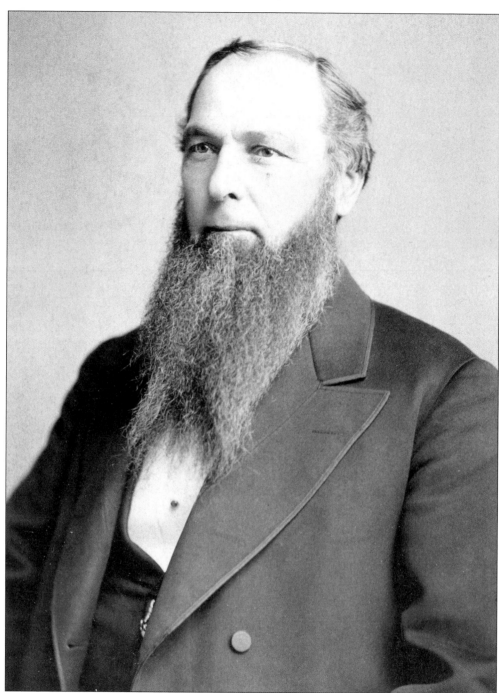

Though many are familiar with him for the hospital that bears his name, Cornelius Aultman made his fortune building agricultural equipment. In 1848, he built five experimental Hussey reapers. After an unsuccessful partnership, Aultman began working for Ephraim Ball in his small plow shop. They formed a partnership in 1851 and built 12 Hussey reapers and 6 threshing machines to sell to local farmers. Ball sold his interest in 1858, and the company became known as C. Aultman & Company.

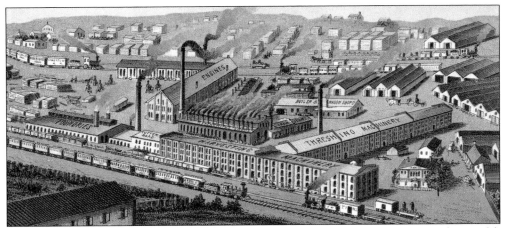

By 1860, Aultman was running the largest reaper and mower company in the world. This drawing depicts C. Aultman & Company's Agricultural Works as it looked in 1890, the same year Aultman Hospital was built.

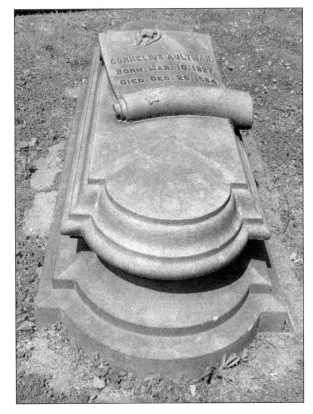

Aultman was a generous man who gave his time and wealth to many local causes. He was named the first president of the First National Bank in 1863. In 1884, he helped organize the Canton Public Library. He died on December 26, 1884, at the age of 57. His family plot is surrounded by a low stone fence, unlike anything else at West Lawn. (The plot is located in Section G.)

After her husband's death, Katherine Barron Aultman began plans to build a hospital in his honor. Elizabeth Aultman Harter, George D. Harter's wife and Cornelius' daughter from a previous marriage, also contributed funds to honor her father.

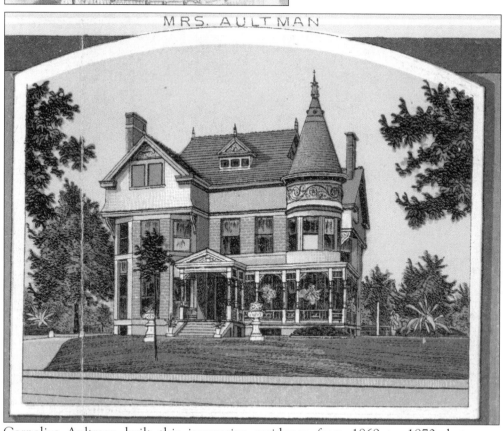

MRS. AULTMAN

Cornelius Aultman built this impressive residence from 1869 to 1870, between Cleveland Avenue and Market Street and 9th and 11th Streets. Katherine continued to live in the home after his death.

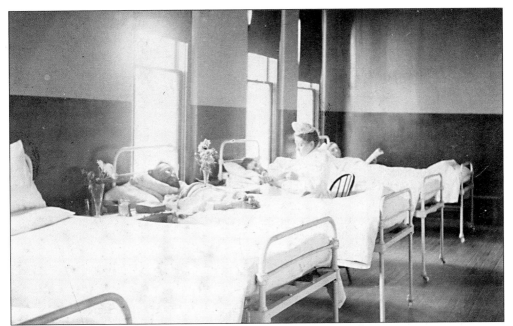

A hospital was a novel idea at the time, and there were very few in communities across the nation. Aultman Hospital was the first medical facility to be built in Stark County. The cornerstone was laid in September 1890, and the hospital officially opened in January 1892. There were 40 rooms with steam heat, and patients paid $1 a day, though a private room was a bit more. This photo of one of the wards was taken in 1898.

Mrs. Catherine Meyer of 151 West Tuscarawas Street was the hospital's first patient. She fell on an icy sidewalk and fractured her leg. Out of the 70 patients admitted within the first nine months, 30 required surgery and only seven died—a pretty good track record for the time! This photograph of the operating room was taken around 1900.

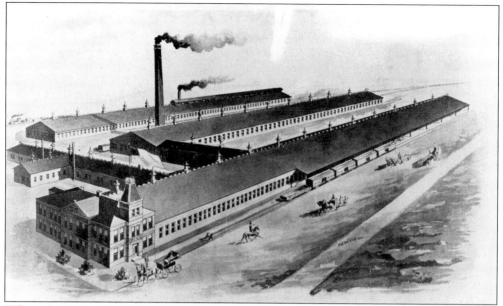

When the Berger Manufacturing Company was organized in 1886, Ed Langenbach was the firm's only salesman. Berger made conductor pipe, metal roofing, and steel ceilings. By 1895, the company was manufacturing 61 different products.

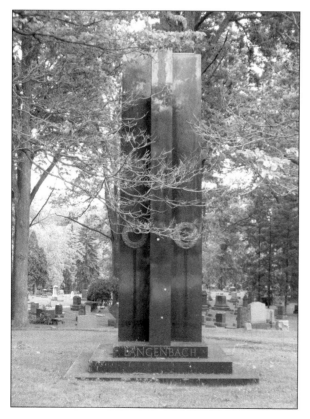

Langenbach was involved in several acquisitions and mergers. He created a network of steel and metalwork plants that would eventually form the nucleus of Republic Steel when it was created in 1929. He married Rosa Janson in 1912 when he was 51 years old. He died in September 1934. (The plot is located on the "island" between Sections E, D, and P.)

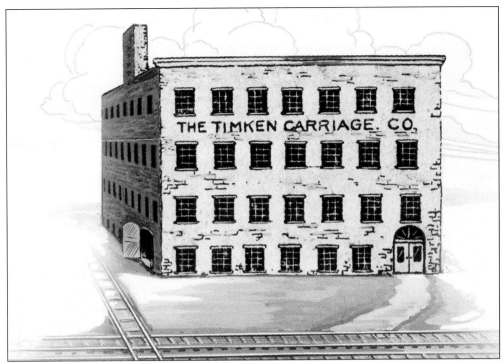

The Timken family began their business in St. Louis where they manufactured carriages and wagons with roller bearings specially designed to make the ride smoother. With the invention of the automobile, Henry H. Timken wisely chose to begin manufacturing roller bearings for cars.

As the business continued to grow, the family began looking for a place to expand their operations. They chose Canton for its proximity to both the steel industry and the blossoming young auto industry, which was centered around Cleveland, Toldeo, and Detroit at the time. On September 23, 1901, the Timkens bought five lots on Dueber Avenue and 20th Street SW. By 1902, production began in Canton with 25 employees. Within a few years, more than half of the participants in the Automobile Show at Madison Square Gardens in New York City were equipped with Timken bearings.

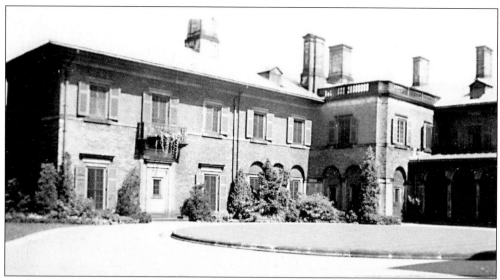

With wealth comes luxury accommodations. Timken built his extravagant mansion in 1915. When it was completed, the Timken mansion was one of the finest homes in the city.

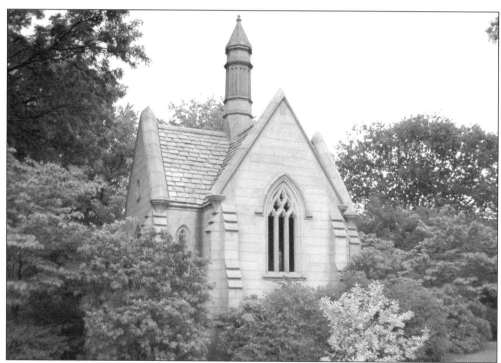

Timken enjoyed hunting, fishing, playing cards, and reading. He was the first president of the Chamber of Commerce when it was organized in 1914. He purchased the *Canton News-Democrat*, renamed it the *Canton Daily News*, and sold it in 1923. He led the reward fund when newspaper publisher Don Mellett was gunned down in his driveway in 1926. When Timken died in 1942, there were 10,000 people employed at his company, which had become the largest manufacturer of tapered roller bearings in the world.

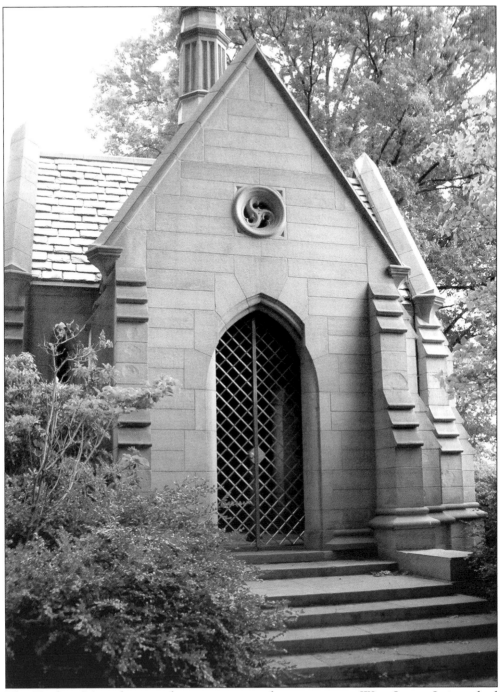

The Timken Mausoleum is the most spectacular structure at West Lawn. It is tucked away in the northeast corner of the cemetery, surrounded by trees. (The mausoleum is near Section 27.)

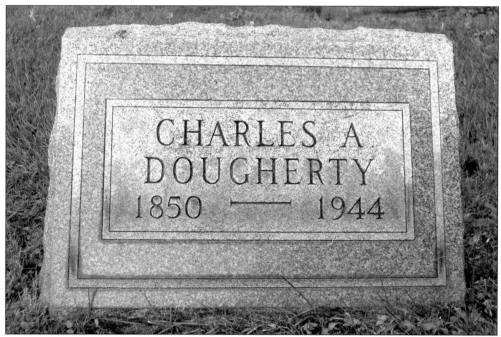

Charles A. Dougherty, who ran a real estate business, was one of the organizers of Canton's Board of Trade in 1885. He knew the city's greatest need was bringing new industries to town, and he went out on the road to convince people to move their businesses here. Through Dougherty's efforts, Henry Timken, John Carnahan, and John Dueber, just to name a few, relocated to Canton. He received no salary for his work and traveled around the country at his own expense. (His grave is located in Section O.)

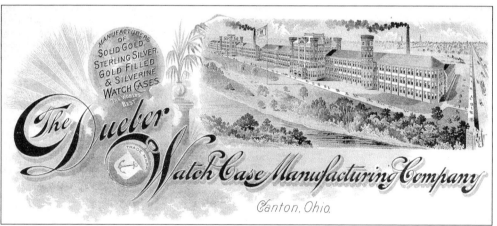

William W. Clark was president of the Canton Board of Trade when John C. Dueber, who manufactured high quality watch cases, purchased the Hampden Company, makers of watch movements. Dueber was looking for a place to move his new combined factory, where a watch would be "made complete" for the first time. Clark led the negotiations that convinced Dueber to come to Canton. Ground was broken for the new building in October 1886. Clark was elected the first president and treasurer of the Hampden Watch Company, a position he held until 1895 when Dueber himself took over.

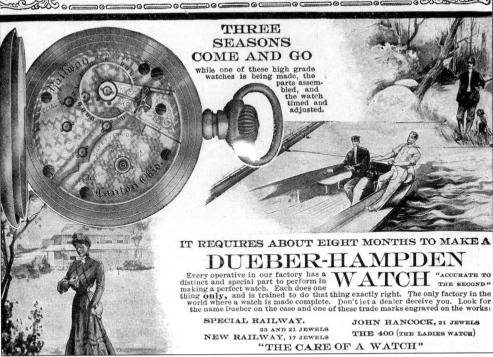
(*above*) This advertisement describes the painstaking methods used to handcraft a Dueber Hampden watch. The company pioneered the 17-jewel movement, which they combined with exquisite 14k gold cases, to create the finest timepieces ever made. A Dueber Hampden watch's signature feature was its elaborately engraved watchcase. Today these watches are highly sought after antiques, with a lofty price tag.

(*right*) Clark was the president of the Diebold Lock & Safe Company for many years. He was also known for donating property on the corner of Cleveland Avenue and 3rd Street SW as the site of the new library building. The building opened in 1905, the same year Clark died. (His plot is located in Section F.)

23

John E. Carnahan came to Canton in 1897 after Charles A. Dougherty visited and convinced him to build a roll and machine factory here. Six acres on Henry Avenue were donated for the company, which began operations in 1899.

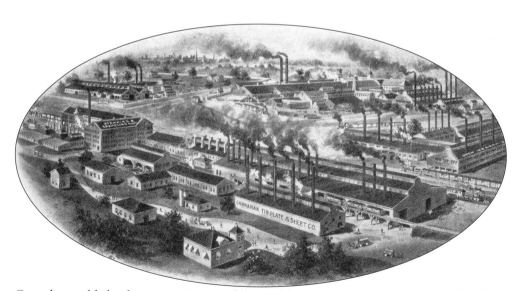

Carnahan sold the factory in 1901 and focused his efforts on the Carnahan Tin Plate Mill, pictured here in 1905. He was the company's president until 1922. His next project was the Carnahan Stamping and Enameling Company.

Carnahan married Mary Stacey Thomas of Armstrong County, Pennsylvania, in 1874. They had six daughters and one son.

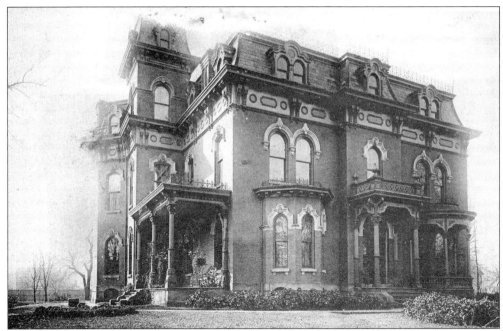

Carnahan also pursued business interests in mining, real estate, steel, oil, and even a banana plantation! His success in all of his endeavors allowed him to build this grand mansion at 810 West Tuscarawas Street.

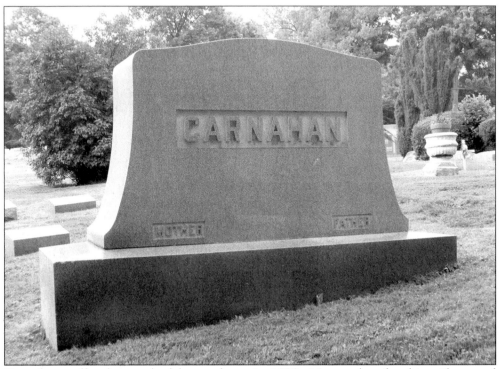

Carnahan suffered a cerebral hemorrhage in 1929, 14 months after his wife passed away. He died at his home on July 2, 1936. (His grave site is located in Section W.)

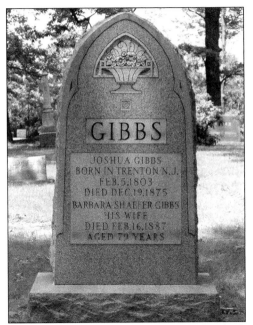
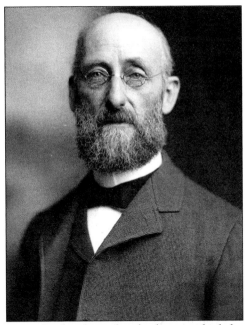

(*left*) A prehistoric glacier gave Stark County rich, fertile soil, which was ideal for agricultural pursuits when the pioneers began heading west. Joshua Gibbs moved to Canton in 1824 and began to improve upon existing plow designs for local farmers. He patented his bar share plow in 1836, which was sold throughout Ohio, Indiana, Michigan, and Illinois. (His grave is in Section B.)

(*right*) When Joshua retired in 1856, his son Lewis (shown here) took over the business with his brothers Martin and William. They renamed the company Lewis Gibbs and Brothers.

In 1870, Lewis formed a partnership with John Rex Bucher and founded the Bucher and Gibbs plow company. They manufactured the "Imperial Plow." In 1891, Lewis Gibbs left the Bucher and Gibbs Plow Company to devote his time to the Gibbs Lawn Rake Company, which he had organized with his

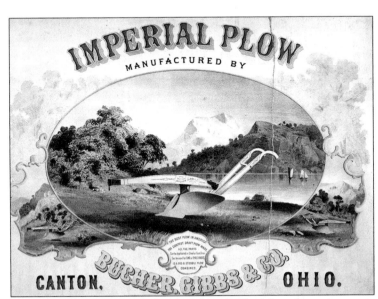

sons Elmer and Alvin in 1884. They changed the name to Gibbs Manufacturing Company in the 1890s and expanded their product line to include knitting needles, crochet hooks, embroidery hoops, and stocking darners.

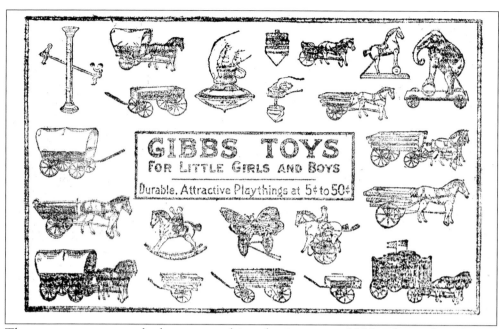

The company entered the toy making business in 1896 when they began manufacturing a top that read "I Spin for McKinley." This ushered in a new era for the company that would catapult them to the forefront of the toy industry. Their moving mechanical animals and wagons were favorites and continue to be coveted treasures today. This print was found in a large ledger book where the company kept a copy of all the printing plates used in their advertisements and catalogs.

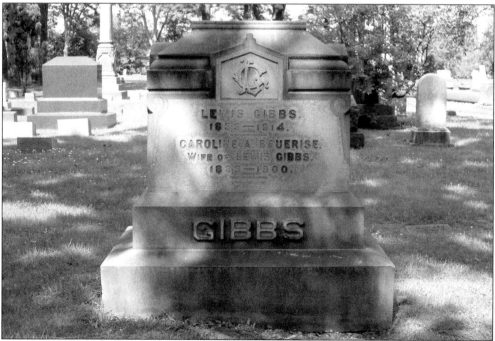

Lewis Gibbs died on April 4, 1914, at the age of 80. (He was laid to rest in Section H.)

The Hoover family legacy began with the tannery operated by Daniel Hoover after the Civil War. He and his wife Mary are the parents of William H. "Boss" Hoover, who took over the family business in the 1870s. Boss started making horse collars and saddles. (Dan and Mary's graves are in Section U.) (Portrait courtesy of the Hoover Historical Center.)

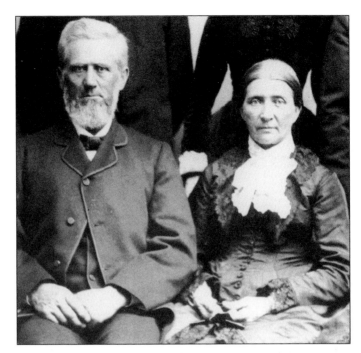

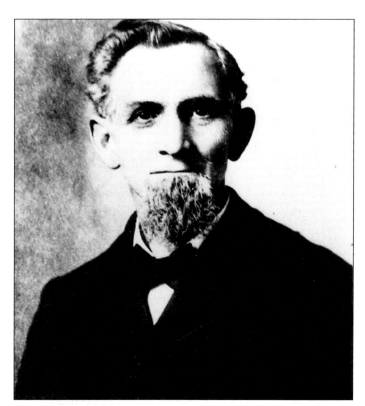

In 1907, a Hoover family friend named James Murray Spangler was working as a janitor in William Zollinger's store. The dust aggravated his asthma when he swept the floor, so he set out to invent a contraption that would use suction to collect the dirt instead of blowing it around the room and into the air. (Spangler's grave site can be found in Section T.)

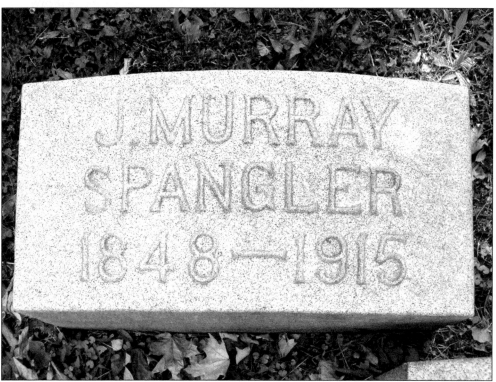

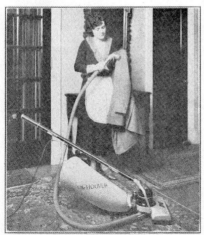

Figure H

This nozzle-brush is also ideal for cleaning mantels made from rough cut bricks, and for removing dust from other uneven surfaces. Clothing and hats may also be cleaned and

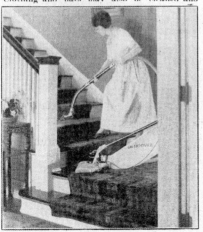

Figure I

freshened with it. (See **Fig. H.**)

The risers of stair carpets can also be cleaned with this convenient tool. This part of the carpet is not walked upon and so is only subject to light surface dirt which suction will remove. (See **Fig. I.**)

Where the brush is not desired it is very easily removed simply by releasing the latch and lifting the nozzle out of the groove in which it is held. Cleaning with the aluminum nozzle is illustrated in Figure J. Use this nozzle also for cleaning furs, as it is not advisable to brush them.

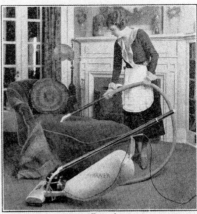

Figure J

Flat Nozzle

This piece, No. 3783, is especially provided for use in places difficult to reach with a larger-mouthed attachment. With it, or with the end of the hose itself, No. 3773, dirt and dust can be suctioned from small places and crevices.

It is ideal for cleaning hot air registers, the interiors of automobiles and for similar uses. For suctioning dust from pockets in clothing it will be found most handy.

To Connect Hose Attachment for Blowing

It will be noticed that the hose attachment has a "hook" and a slotted "ear" which cor-

William H. "Boss" Hoover liked the "contraption" and saw potential in Spangler's invention, so he purchased the patent from Spangler in 1908 and began producing the Hoover Suction Sweeper. This is a page from an early instruction book that came with a new vacuum cleaner, *c.* 1918.

Boss Hoover was a beloved figure in North Canton. He died in 1932. Despite the family's wealth and local fame, their graves are quite modest, blending in seamlessly with the markers that surround them. (His plot is in Section U.)

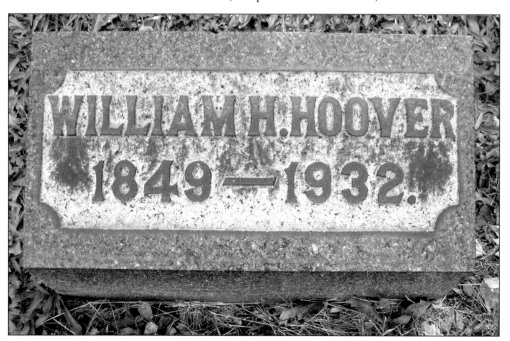

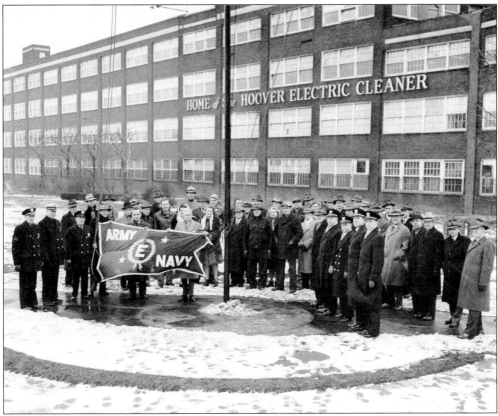

Like many local businesses, Hoover converted its factories over to war production during World War II. The company won the Army-Navy "E" Award five times, which earned them the right to fly the Army-Navy E Flag with four stars on it. This photograph shows the employees raising the flag. (Photograph courtesy of the Hoover Historical Center.)

Herbert William "H.W." Hoover, son of Boss Hoover and then-president of the company, arranged for the safe evacuation of many English children during World War II. Their parents worked at Hoover's branches in England. H.W. Hoover is shown here with the evacuees who were brought to North Canton. (Photograph courtesy of the Hoover Historical Center.)

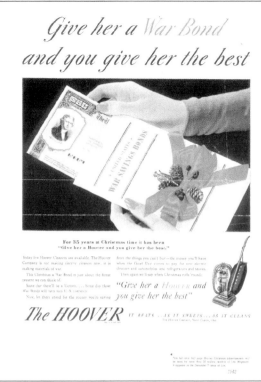

In 1944, two of Hoover's ads were included on the list of the 100 most outstanding wartime ads published that year. One of them was this Christmas ad, featuring the slogan "Give her a war bond, and you give her the best." Hoover produced a staggering amount of war goods, including the top secret VT radio fuse, which was second only to the Atomic Bomb in terms of secrecy. (Photo courtesy of the Hoover Historical Center.)

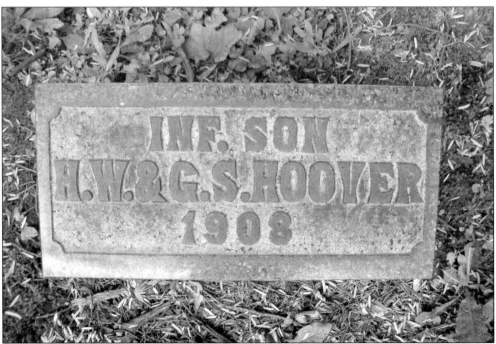

Though H.W. Hoover is buried in North Lawn Cemetery, the "sister cemetery" of West Lawn, the infant son born to him and his wife Grace Steele Hoover is buried here in the Hoover family plot. (The Hoover family plot is located in Section U.)

Three

BUSINESSMEN

Day to day life in any city revolves around meeting the needs of its citizens. Where we buy our clothes, do our banking, and get our news creates the memories of our "hometown." The Canton of yesteryear was sprinkled with homegrown stores like Zollinger's and Stern & Mann's and big businesses like Harvard Dental and Noaker's Velvet Ice Cream.

Some establishments are long forgotten. Others endure. People still get a bite to eat at Bender's, read the *Repository* every day, and cook up Sugardale bacon on weekend mornings. Though many things about Canton have changed, some ties to the past remain.

The stories that unfold here exemplify the ingenuity of those who came before us. Their business sense, combined with hard work and countless hours, created some of Canton's most beloved businesses.

A black raspberry bush has grown up around the graves of Luther Ballard and his wife Rebecca Whitcomb.

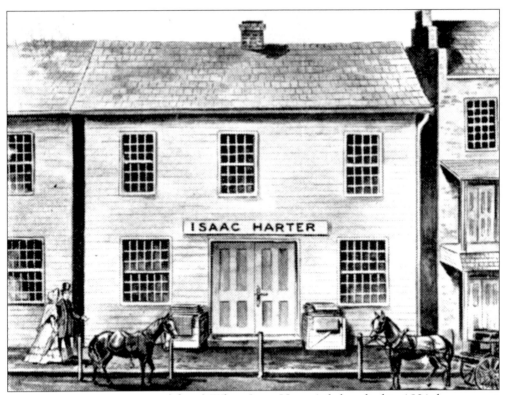

(*above*) When Isaac Harter's father died in 1821, he was sent to live with his sister, Mrs. George DeWalt, who found him a job as an errand boy at a general store owned by William Christmas. He worked for 10 years without pay as an apprentice. When he turned 21 in 1832, Christmas made him a partner. Four years later, Christmas died, leaving Harter with a well-established store at a young age.

(*left*) In the early days, several Canton banks failed, leaving the growing town without a stable financial institution. Though he already owned a flourishing business, Harter formed the Savings Deposit Bank of Harter, Trump, Wikidal & Co. For the first six years, he was not an active partner of the bank, but he eventually decided to sell his store and become a full time banker.

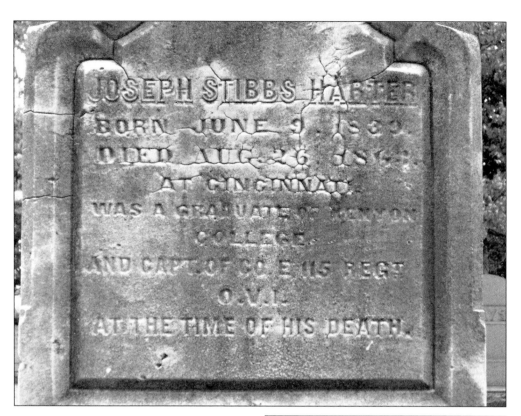

(*above*) Isaac's son Joseph Stibbs Harter was killed during the Civil War in the barracks when a fellow soldier in Company E of the Ohio Volunteer Infantry (OVI) dropped a loaded revolver and accidentally shot him. (This site is found in Section G.)

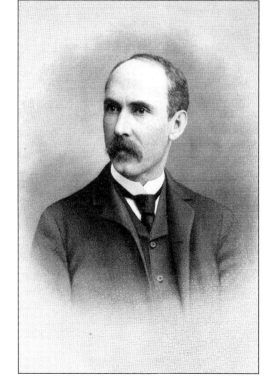

(*right*) Isaac's other two sons, George D. and Michael D., returned home from the Civil War safely and went into the banking business with their father. This is a portrait of George.

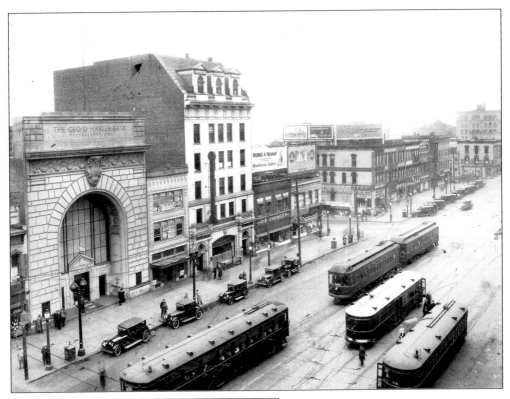

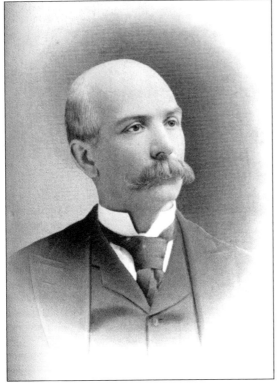

(*above*) Before long, the brothers wanted to run their own bank. They asked their father for a $20,000 loan to start the George D. Harter and Brother Bank. Instead of viewing it as competition for his own bank, Isaac praised the motivation and ambition of his two sons and happily loaned them the money. This photo, showing the bank on the far left with the large arch over the door, was taken in 1925.

(*left*) Michael was not all that interested in banking and moved to Mansfield in 1867 to head up the Aultman and Taylor Threshing Machine Company. He retained a silent interest in the George D. Harter Bank, but was never an active part of the business.

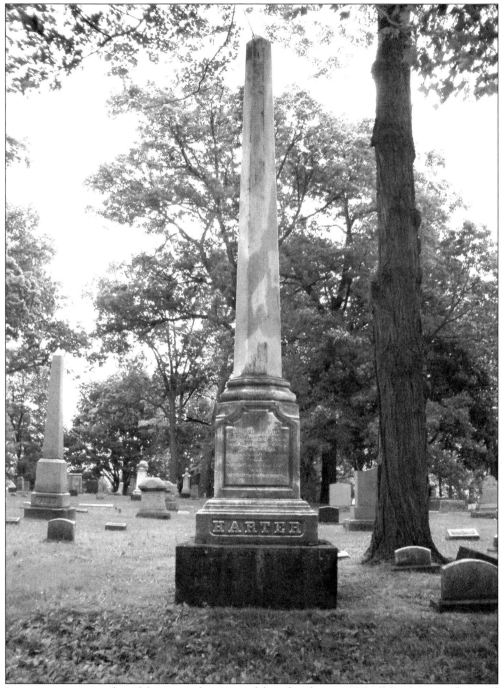

Isaac never retired and kept working until his death in 1876. (His grave is located in Section G.)

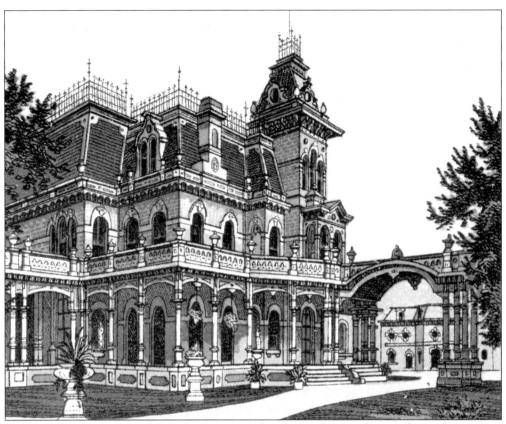

George Harter married Elizabeth Aultman, daughter of Cornelius Aultman, in 1869. They lived in this spectacular mansion. This drawing was done in 1890.

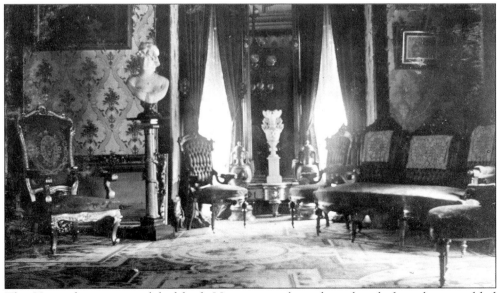

The Harter home exemplified high Victorian style with its lavish furnishings, gilded picture frames, and wallpaper and carpeting that appear to clash in modern tastes.

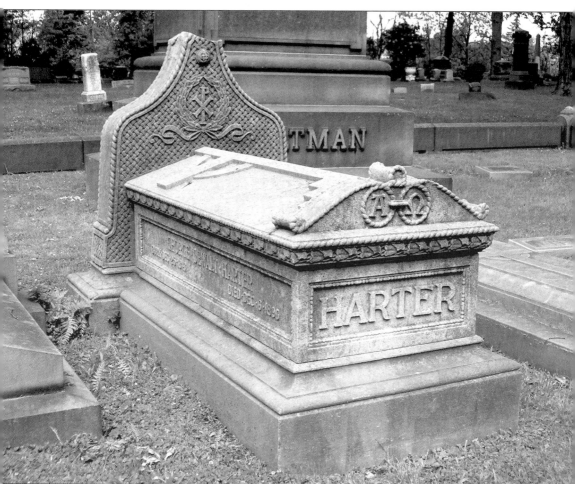

George Harter died suddenly of a heart attack in 1890 when he was just 47 years old. He had a special interest in the YMCA and died just two weeks before the new building was finished. Harter was specially honored at the opening ceremonies. At the base of his stone are the Greek letters Alpha and Omega, signifying the beginning and the end. He is buried in the Aultman family plot. (The family plot is in Section G.)

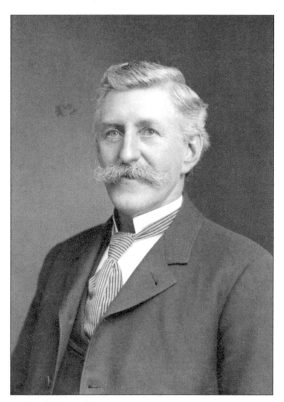

William D. Theobald opened Canton's first plumbing business at the southeast corner of South Market Avenue and 4th Street. (His plot is in Section N.)

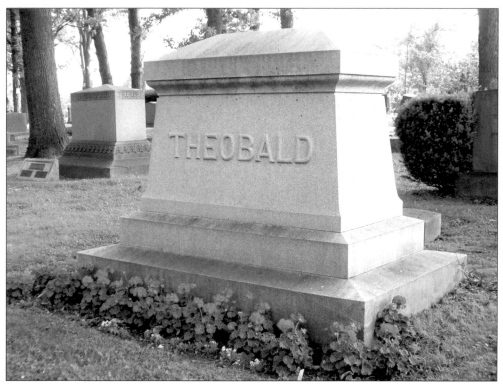

Theobald married Carrie E. Bachtel, and they lived at the end of the horsecar line at 1210 South Market Avenue. The drivers stood outside on an open platform, no matter what the weather was like. Throughout the winter, Mrs. Theobald kept a pot of coffee boiling on her stove, and all the drivers had a standing invitation to come and warm themselves during their five to ten minute wait at the end of the line.

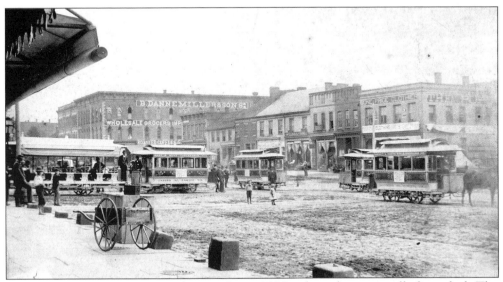

The horsecars ran in Canton from 1884 to 1889, when they were all electrified. The cars were scheduled to run every 10 minutes during morning rush hour from 6:10 a.m. to 7 a.m. and at 20-minute intervals the rest of the day. Each trip took 40 minutes, and the fare was 5¢. At the end of the line, the horses were unhitched and taken to the other side of the car, making the back of the car become the front.

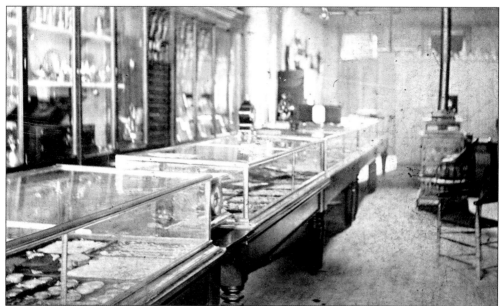

George M. Deuble visited Canton in 1830 and found no watchmakers or jewelers in town. He was a German immigrant who had learned to make clocks and watches before coming to America. He moved here in 1831 and opened Deuble's Jewelry in 1840. He made the first two village clocks. This photograph shows how the store looked in 1883.

Deuble Jewelry rarely advertised in the newspaper. When their first ad appeared on June 3, 1869, it ran unchanged for an entire year. It was a two column ad, two-and-a-half inches high, and was so packed with information that readers needed a magnifying glass to decipher the tiny type! They advertised themselves as the "Old & Reliable Jewelry Establishment, at the old and well known place on the East Side of Public Square." (Deuble's plot is found in Section H.)

Norman Deuble was an avid bicycle rider who participated in the high-wheeler races sponsored by the Fire Department from 6th Street to Tuscarawas Avenue. He was riding a bicycle like the one shown here (the two men are not identified) when the person next to him fell. Norman hit him and fell himself, sustaining serious head injuries. His was the first operation performed in Aultman Hospital. Unfortunately, there was nothing the doctors could do to save him, and he died at the young age of 28.

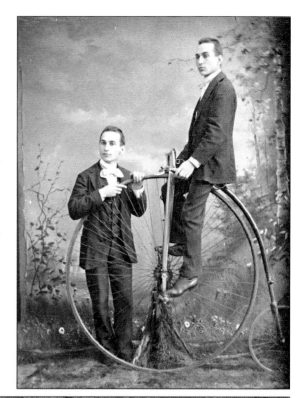

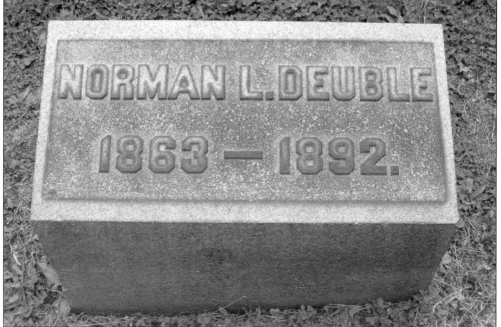

The Deuble family started an interesting tradition that was carried on for generations. The sons of the family were offered $500 on their 21st birthdays if they did not smoke or drink by that time. As a matter of family pride, most of the sons in the family qualified for the prize. (The Dueble plot is in Section H.)

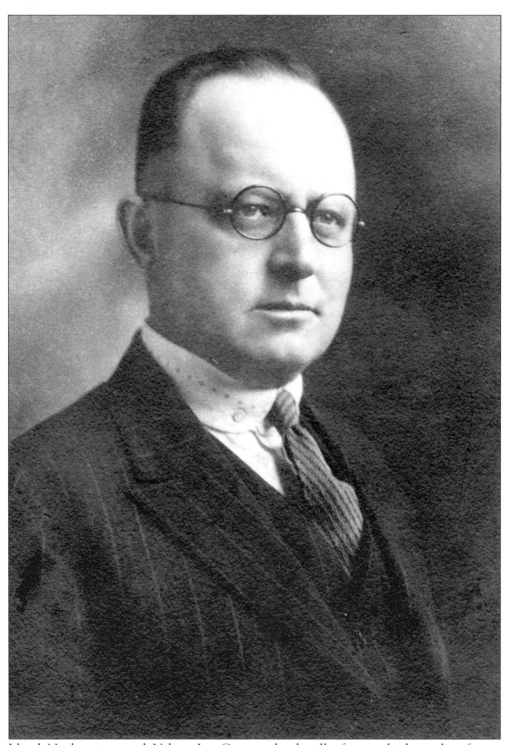

Lloyd Noaker invented Velvet Ice Cream, the locally famous high quality frozen delight. By 1905, his company was producing 50 gallons of ice cream a day using a hand-cranked ice cream maker.

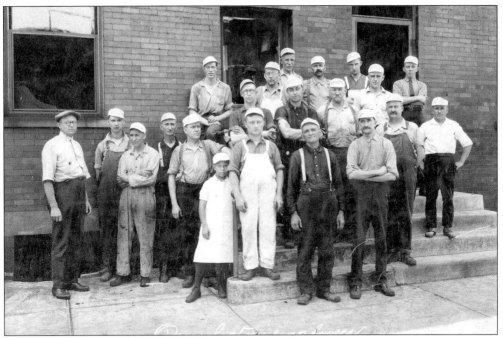

Employees had dressing rooms where they changed from their street clothes into crisp, white suits. This photo was taken in the 1920s.

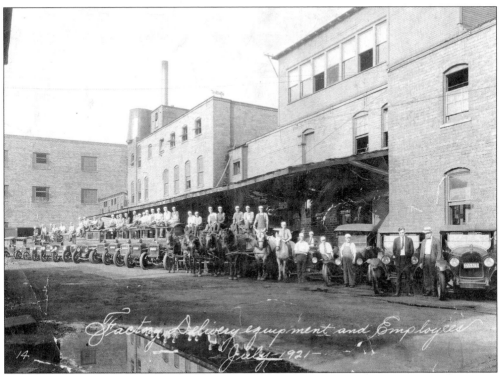

By the 1910s, the new factory could produce 125 gallons an hour for a total of 3,000 gallons a day. Their slogan was, "It's not quite as cheap as some, but just a little bit better."

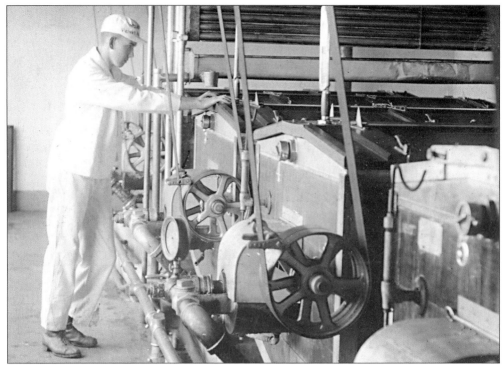

In 1911, Noaker took out a full-page ad in *The Repository*. The company advertised that their ice cream was "made in the most scientifically and perfectly equipped plant in the United States." They emphasized that no human hands ever touched Velvet Ice Cream.

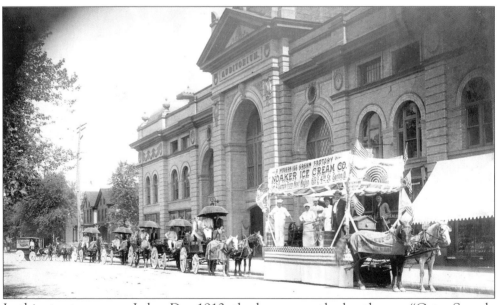

In this street scene on Labor Day 1912, the banner on the booth says, "Get a Sample from Next Wagon." Each wagon's wheels and umbrella say "Noaker's Velvet Ice Cream." They are lined up in front of the Auditorium, which was located on North Cleveland Avenue between 4th and 5th Streets.

Noaker sold his business to the Borden Company in 1929. He received a check at 3 in the afternoon on February 19. That night at 11 p.m. he suffered a fatal heart attack. He was 52 years old. (Noaker's plot is located in Section Z.)

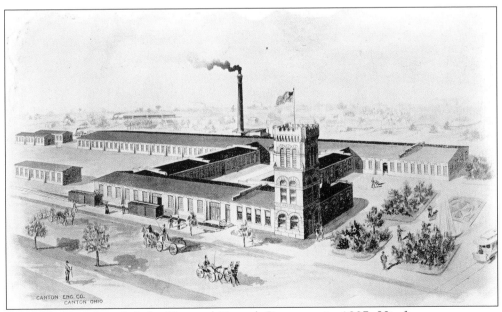

Frank E. Case founded the Harvard Dental Company in 1887. His first career was a teacher in Ashtabula County. He began studying law and was admitted to the bar in 1871. He began making dental chairs in his basement in 1887. In 1896, he built an 85,000-square-foot factory at 13th Street and Ohio Avenue NE.

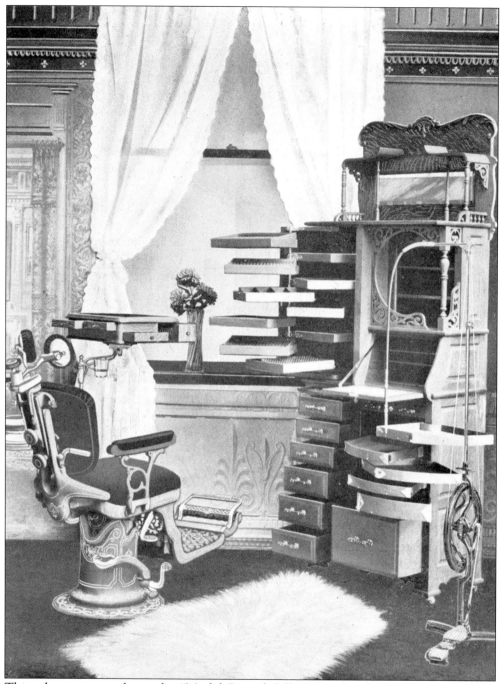

This advertisement shows the "Model Dental Office," outfitted with Harvard's chair, cabinet, and table. It is estimated that one-third of all dental offices in the country had Harvard dental furniture.

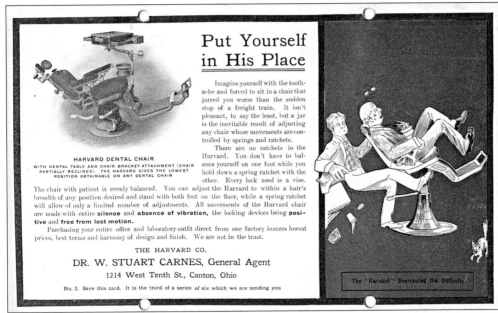

Case was inspired to invent a dental chair when he went to serve as the third person witness for a patient's anesthesia, which was required by law at that time. He saw how difficult it was for the dentist to do his work with the patient's head bobbling around, mostly because the chair didn't recline. This undated advertising card, third in a series of six, explains the benefits to the patient as well.

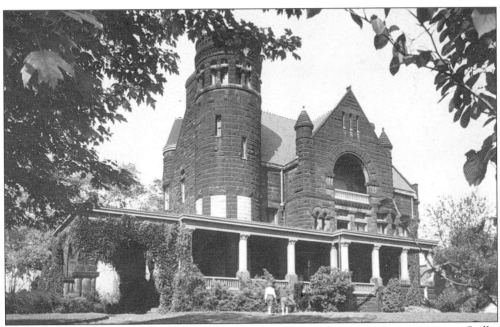

Case dreamed of giving his spectacular mansion to the city for use as an art museum. Sadly, he lost his fortune in the Depression and was not able to see his dream fulfilled. After his death, Fred Preyer bought the home, renovated it, and turned it over the Canton Art Institute anonymously. His generosity was not made public until his own death.

(*above*) Case was involved with the Front Porch Campaign and was chosen as a member of the executive committee who handled arrangements for President McKinley's funeral. He died in 1933. (Case's grave site is in Section N.)

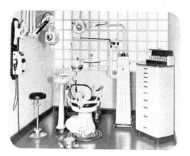
(*left*) Henry E. Weber, a former employee at Harvard, founded the Weber Dental Company in 1898. A Weber "first" was the fountain cuspidor with running water, patented in 1916, which replaced the foul-smelling spittoon-like "spit buckets" on the floor.

PROGRAM *of* EVENTS

BASEBALL GAME called at 9:30
UPSTAIRS vs. DOWNSTAIRS
WM. KARRER, Capt. Downstairs F. KLINK, Capt. Upstairs

—

Dinner at 12 o'clock

—

No. 1. Donkey Contest for everybody
First prize, $1.00

No. 2. Wheelbarrow Race for Men
First prize, $1.00; Second prize, 50c

No. 3. Fifty Yard Race for Ladies
First prize, $1.00; Second prize, 50c

No. 4. One Hundred Yard Race for Men
First prize, $1.00; Second prize, 50c

No. 5. Nail Driving Contest for Ladies
First prize, $1.00; Second prize, 50c

No. 6. Marshmallow Eating Contest for Ladies and Men
First prize, $1.00; Second prize, 50c

No. 7. Fifty Yard Race, Girls 12 years up
First prize, $1.00; Second prize, 50c

No. 8. Fifty Yard Race, Boys 12 years up
First prize, $1.00; Second prize, 50c

No. 9. Fifty Yard Race, Girls 6 to 12
First prize, $1.00; Second prize, 50c

No. 10. Fifty Yard Race, Boys 6 to 12
First prize, $1.00; Second prize, 50c

No. 11. Cracker Eating Contest, Boys and Girls
First prize, $1.00; Second prize, 50c

No. 12. Tug of War for Men
Prize, box of cigars

No. 13. Tug of War for Ladies
Prize, box of candy

Horse shoe games all day

—

❧ Everybody wear their badges in order to receive full benefit at this picnic.

❧ Coffee, Lemonade and Ice Cream will be served.

❧ Bring your own cups and spoons.

—

COMMITTEE

| Wm. Karrer | J. O. Weber | C. Scheurer |
| E. Horger | F. Moran | F. Klink |

This is the program from the First Annual Basket Picnic for the employees of the Weber Dental Manufacturing Company held on Saturday August 27, 1921, at the Cedars.

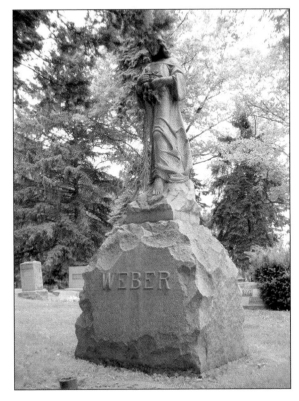

Canton's two dental companies operated simultaneously until they merged in 1937, after both founders had died. (The Weber grave is in Section Z.)

(*left*) John Saxton came to Canton when he was just 22 years old, looking for someplace to start a newspaper. On March 30, 1815, he published the first issue of *The Repository*, one of the earliest newspapers in Ohio, for Canton's 500 residents. It was a weekly paper and would remain that way until it became a daily in 1878. Subscriptions were $2 a year.

(*below*) Early newspapers looked much different than they do today. There were no pictures, and the type was extremely small. Saxton's first editorial read, in part, "Truth shall be his guide, the publick [sic] good his aim . . . well-informed men, of all parties, are invited to make it a Repository of their sentiments."

THE OHIO REPOSITORY.

Vol. I.] THURSDAY EVENING, APRIL 5, 1815. [No. 2.

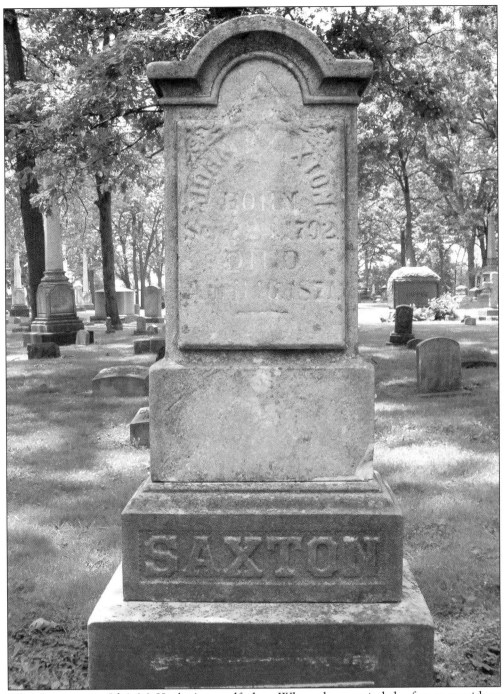

John Saxton was Ida's McKinley's grandfather. When she married the future president in 1871, Saxton was too sick to attend the ceremony. He died shortly afterwards at the age of 79. (Saxton is laid to rest in Section F.)

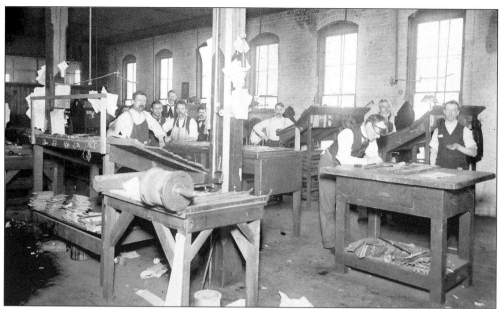

George B. Frease took over as editor of *The Repository* in 1886. He turned the newspaper into a nationally known publication. Frease was one of William McKinley's closest friends and served as the executive chairman of his famous Front Porch Campaign. This photograph depicts the type-setting room in the 1890s. Frease acquired the first type-setting machines in 1896. Until then, all of the type was set by hand.

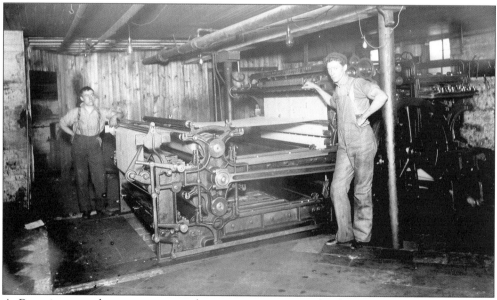

A *Repository* worker pauses near the printing press in the late 1890s. Frease started a Sunday edition in 1892. During the afternoon and evening on the day McKinley was shot, Frease published 10 extra editions in less than three hours, totaling 16,000 copies. News of the president's death on September 14, 1901, reached *The Repository* seven minutes after he died. Seven minutes later, a special edition rolled off the presses with a black border.

(*above*) Frease died at the age of 67. (Frease is buried in Section F.)

(*right*) After Isaac Harter left the mercantile store, he sold the business to David Zollars, pictured here, who had been one of his employees. David's son Lewis entered the business in 1884, and the name was changed to David Zollars & Son. They sold groceries, shoes, hats, and other goods.

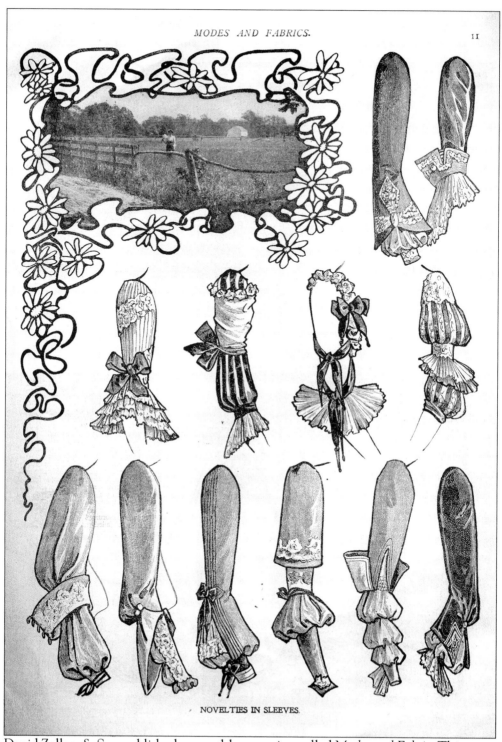

NOVELTIES IN SLEEVES.

David Zollars & Son published a monthly magazine called *Modes and Fabric*. This page, from the August 1902 issue, shows the various sleeve styles that were available.

The store was located at 115 South Public Square, the center of Canton's downtown business district. The Zollars family was always involved in the community. When the YWCA started offering sewing classes for young girls in the 1910s, Lewis Zollars donated bolts of gingham for them to use.

David Zollars died in 1912. (Zollars' plot is in Section O.)

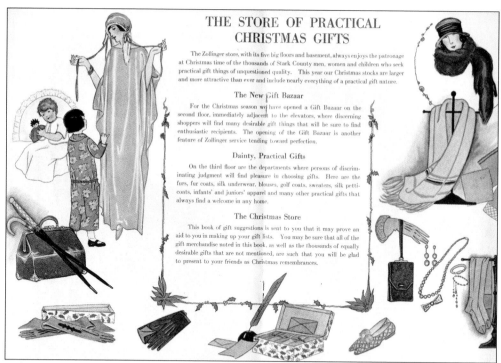

THE STORE OF PRACTICAL CHRISTMAS GIFTS

The Zollinger store, with its five big floors and basement, always enjoys the patronage at Christmas time of the thousands of Stark County men, women and children who seek practical gift things of unquestioned quality. This year our Christmas stocks are larger and more attractive than ever and include nearly everything of a practical gift nature.

The New Gift Bazaar

For the Christmas season we have opened a Gift Bazaar on the second floor, immediately adjacent to the elevators, where discerning shoppers will find many desirable gift things that will be sure to find enthusiastic recipients. The opening of the Gift Bazaar is another feature of Zollinger service tending toward perfection.

Dainty, Practical Gifts

On the third floor are the departments where persons of discriminating judgment will find pleasure in choosing gifts. Here are the furs, fur coats, silk underwear, blouses, golf coats, sweaters, silk petticoats, infants' and juniors' apparel and many other practical gifts that always find a welcome in any home.

The Christmas Store

This book of gift suggestions is sent to you that it may prove an aid to you in making up your gift lists. You may be sure that all of the gift merchandise noted in this book, as well as the thousands of equally desirable gifts that are not mentioned, are such that you will be glad to present to your friends as Christmas remembrances.

When William Ruel Zollinger relocated his department store at 2nd Street and Market Avenue North in 1902, people thought he was crazy! Many believed it was too far outside the business district, which was centered around Public Square. He proved to be a visionary as the business district slowly crept north. His store was nicknamed "The Daylight Store" because of the bright lights he used. This is a page from his Christmas catalog, probably between 1910 and 1920.

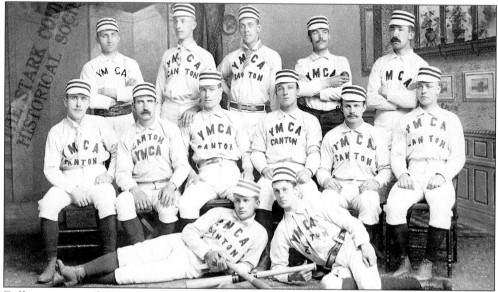

Zollinger was a big supporter of the YMCA. This photo shows the YMCA baseball team, probably around 1890.

Zollinger was a member of the group who picked out the site for the Brookside Country Club. He was also a Mason. Murray Spangler worked at his store when he invented the vacuum cleaner. Zollinger died in 1922. On the day of his funeral, most retail stores downtown closed from 2 to 4 p.m. in his honor. (Zollinger's grave is in Section 29.)

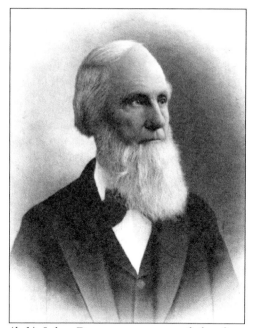
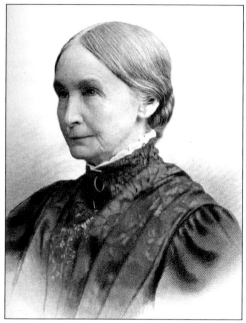

(*left*) John Danner was one of the first native-born Cantonians. He patented his famous revolving bookcase in 1874. By 1880, he had sold more than 6000 to public offices, lawyers, clergy, physicians, businessmen, libraries, courts, reading rooms, and literary and musical societies.

(*right*) John Danner married Teressa in 1847. The couple celebrated their 60th wedding anniversary in 1907. Their daughter Alice Danner Jones wrote the poem on the opposite page to commemorate the special occasion.

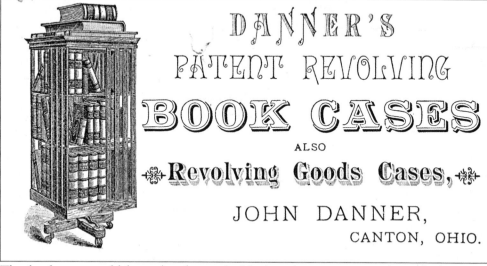

DANNER'S PATENT REVOLVING BOOK CASES

ALSO

Revolving Goods Cases,

JOHN DANNER,

CANTON, OHIO.

The bookcases could be ordered in oak, black walnut, western ash, and Philippino mahogany, and were priced from $10 to $15. In one testimonial, Hon. John M. Kirkpatrick of Pittsburgh wrote, "I am greatly pleased with your No. 4 Standard Case, and only wonder now that I have it in use, that I did not have it long ago. It is indeed unsurpassed by any thing in the shape or form of a Book Case."

The following poem was composed by the Danners' daughter Alice, in honor of their 60th wedding anniversary in 1907.

John and Teressa

Poets have written of lady
and knight,
Written the tender romances
of old,
But who the beautiful story
of love
Of John and Teressa, has
ever told?
The story beginning when
life was young
When hearts were hopeful
and love was sweet,
The story whose ending will
never come
Till cycles of time and
eternity meet.

For John and Teressa, are
lovers still
Tho backs are bending and
heads are grey,
Tho dimples and frils [sic],
and coquetry's arts,
Belong to the things of
yesterday.
Bordering paths from long-
ago
Old friends are sleeping on
either side,
And God has been good
Whose love has spared
The white-haired groom and
his sweet-faced bride.

John and Teressa, your
children stand,
Before you in reverence
deep and true,
For all that we are or may
hope to be
We owe to the beautiful
teaching of you.
When childish troubles
seemed too great
To you for comforting we
came;
And now when cares

maturer vex
We find that still we do the
same.

John and Teressa, the world
today
Holier throbs for work you
have done,
And gentler for you
humanity's hand
Deals with the erring and
sorrowing one.
Unselfishly thoughtful you
little may know
How loved by your friends
and honored are both,
How hundreds, rejoicing,
are standing today
Pledged fondly to you in
friendship's troth.

John and Teressa, you've
climbed life's hill
And rested in valleys of
peace together,
The clouds have lowered or
suns have shone
You've fearlessly faced all
kinds of weather.
There's recompense waiting
beyond the last hill
Where lie the plateaus of
eternal rest;
For if ever reward to saints
is given,
John and Teressa deserve the
best.

John and Teressa, tho sixty
years
Have passed since wedding
bells were rung,
Love's anthems now hold
deeper tones
Than those light hearted
lovers sung;
For chords and trills and
needed rests
And eve minor notes of pain,

Form one complete
harmonious whole
fit prelude to an angel's
strain.

John and Teressa, tho oft'
you speak
Of other lands so wondrous
fair,
Yet we still need your
guidance here,
And heaven is full without
you there.
No prouder children ever
stood,
Than we who call you
"parents" stand,
While better home than you
have made
Holds not America's fair
land.

John and Teressa, to you
both
We drink in water pure and
clear;
Bright days, rich hopes and
memories sweet
Make better every passing
year.
May those you've helped
their trophies bring
Of love, and lay them at
your feet;
Full harvests gleaned from
ripened fields
Where your hands sowed
the grains of wheat.

–by Alice Danner Jones

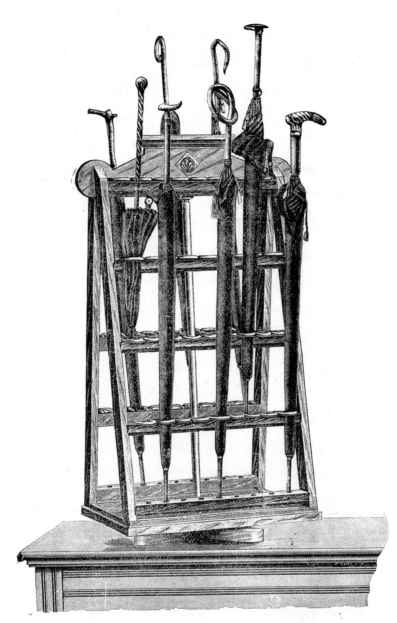

No. 72 Umbrella Rack—Price $8.00.

This is a revolving rack and holds six dozen Sun Umbrellas or Parasols, and is intended to set on counter or table. It is 18 inches in diameter and 36 inches high.

This rack is also admirably adapted for the display of Canes.

Danner was a supreme tinkerer and inventor who held several patents for his inventions. He made and sold several other products, including the umbrella rack shown here. He also produced collapsible hook racks, dry goods cases, stools, and other furniture.

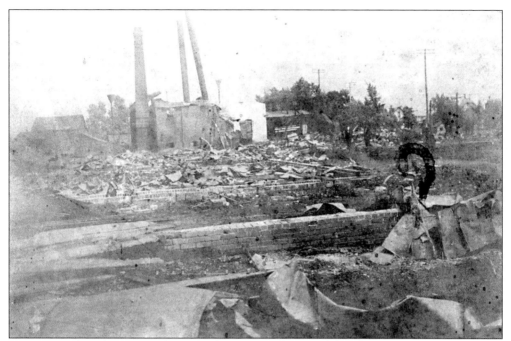

A catastrophic fire swept through the entire plant and leveled it completely in May 1903, when Danner was already 80 years old. The fire caused $100,000 worth of damage, and he only had $40,000 worth of insurance. Adding to the loss, many workers owned their own tools and kept them at the factory. Those too were lost. Danner rebuilt the factory, but the business never fully recovered. It was liquidated in 1916.

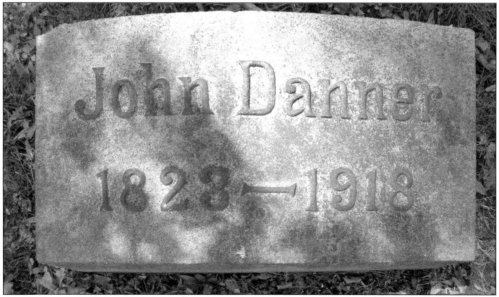

John Danner left his mark on the history of this city by recording his reminiscences in a large volume entitled *Old Landmarks of Canton and Stark County*. Indeed, a community had grown up around him before his very eyes. He watched Canton grow from a town of 700 to a city of 85,000 during his lifetime. (His grave site is in Section F.)

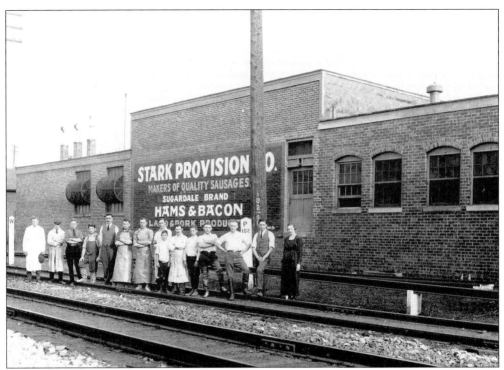

Harry Lavin founded the Stark Provision Company in 1919 with his sons Arthur, Leo, and William. The company, which specialized in hams and luncheon meats, started with just 15 employees and grew to employ over 1,000.

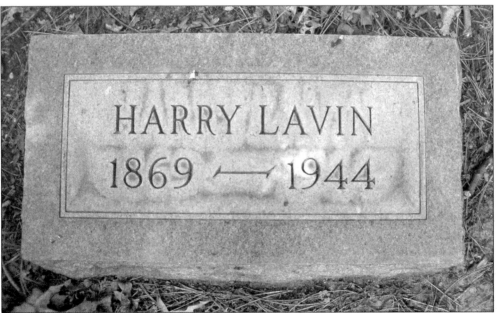

The Lavins renamed the business Sugardale, a combination of their sugar cure process and the original brand name "Farmdale." The company was acquired by Superior's in February 1976. (The Lavin plot is in Section W.)

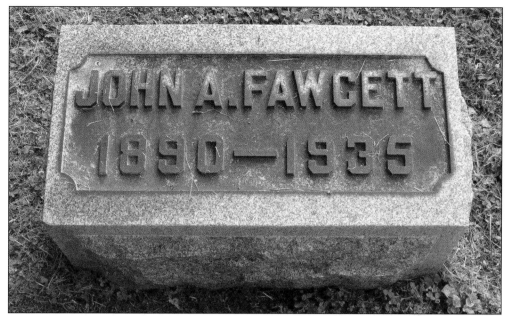

In 1935, Canton lost a beloved civic leader when John A. Fawcett died of pneumonia. He was the president of the First Trust and Savings Bank and was known as an avid McKinley Bulldogs fan. At Mrs. Fawcett's request, the Board of Education cancelled plans to delay a football game so it would not interfere with Fawcett's funeral. (Fawcett was laid to rest in Section N.)

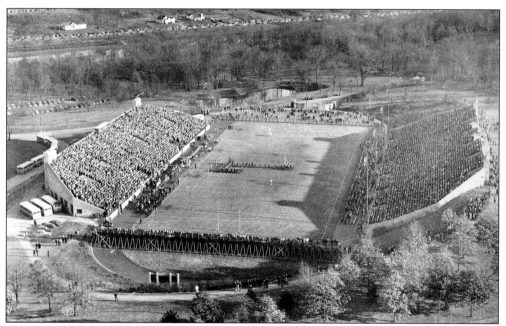

The John A. Fawcett Stadium opened in 1938. The McKinley Bulldogs played the Lehman Polar Bears in the very first game at the stadium, which had seating capacity for 20,000. Official opening ceremonies took place the following year when the $250,000 project was completed.

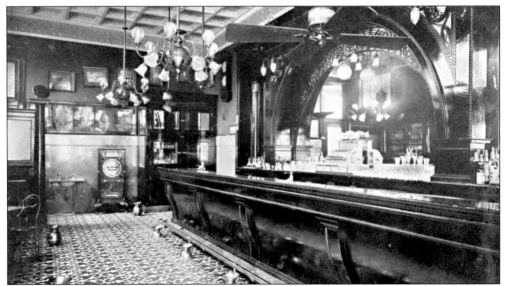

Ed and Anna Bender opened their well-known restaurant in 1902 at the corner of East Tuscarawas Street and Walnut Avenue. In 1907, they moved into the Belmont Building, designed by famed architect Guy Tilden. Saturday nights in the 1910s were often described as "nightmares" by the staff, who dreaded it all week long. The stores downtown were open late, and the businessmen had wives and children meet them for dinner. Whole families crowded in—then they went out shopping and came back for "chili and beer."

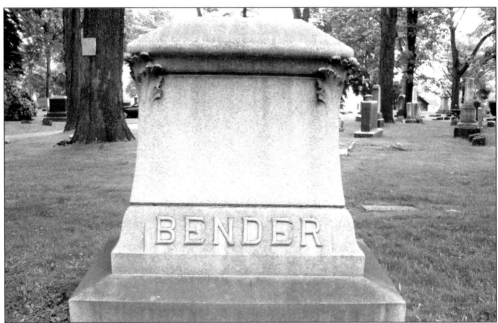

In the 1920s there was a free lunch bar in the back of the barroom, most likely to encourage mid-day drinkers to put something in their stomachs! In 1928, Ed died of appendicitis while on a fishing trip with the Timkens. Anna took over the restaurant, but it closed in 1932 due to Prohibition and the Depression. It was re-opened six months later by the Jacob family. (The Bender plot is located in Section F.)

1888 Expense Account		July	Stern & Mann	
June 4 Miss Mayer Clara	25 00	7	Amt Forward	345 69
4 Lena Lottie	10 00	7	Canton Electric Co	6 75
4 Julia Minnie	6 00	7	Sprinkling	2 00
4 Jett Winnie	6 00	7	Ice	60
4 Electric Light Co	6 75	7	Express	3 00
4 Street Sprinkling	2 00	7	Jett Minnie	9 00
4 Gas Bill	6 56			367 04
6 Express	5 50	9	Clara Lena	11 00
	71 81	9	Lottie Julia	8 00
11 Clara Miss Mayer	25 00	9	Winnie	3 00
11 Lena Lottie	10 00	14	Expressage	3 26
11 Julia Minnie	6 00	14	Water rent	2 50
11 Winnie Jett	6 00	14	Watchman	75
16 Ice	60	14	Blank Pads	1 00
16 Watchman	75	14	Gas Bill	4 99
16 Express	5 13	14	Ice Bill	60
16 Signs	6 50	14	Lottie Winnie	16 00
	59 98			57 10
18 Clara Miss Mayer	25 00	16	Clara Lena	11 00
18 Lottie Lena	10 00	16	Julia	3 00
18 Julia Minnie	6 00	18	Express	60
18 Jett Winnie	6 00	18	Lewis Harting	1 00
18 Ex to Cleveland	5 00	21	Julia	6 00
23 Express TC	5 80	21	N. Y. Herald	10 00
23 Geo Shaver & Bro	2 00			31 65
23 Paper Boxes	2 25	23	Clara Lena	11 00
	60 05	23	Minnie	3 00
25 Miss Mayer Clara	43 00	28	Express	2 25
25 Lena Lottie	10 00	28	Watchman 75 Repair 50	1 25
25 Julia Minnie	6 00	28	postage 65 scrubbing 1 00	1 65
25 Jett Winnie	6 00	28	Sunday M. Times	5 33
28 Cleaning & D. process	10 00	28	Dem Pub Co	12 50
28 Watchman 75 Sup Rep 50	1 25	28	Lena	10 00
30 Expressage	3 93			46 98
	80 18	30	Clara Minnie	9 00
July 2 Mrs H. A. Winterhalter	300 00	30	Ice	60

Stern & Mann, Canton's legendary department store, opened in 1887 when Max Stern and Henry Mann bought Winterhalter Millinery Store on South Market Avenue. This ledger shows the store's expenses for June and July 1888. They listed salaries paid to the original sales staff, including Lottie, Lena, Julia, Minnie, and Winnie. They paid $6.75 to the Canton Electric Company, $6.56 for gas, $2.00 for street sprinkling, 60¢ for ice, 75¢ for the watchman, and $2.25 for paper boxes. There is a listing for $300.00 to Mrs. Winterhalter, presumably a payment for buying her store. (Ledger courtesy of Mr. and Mrs. Robert Mann.)

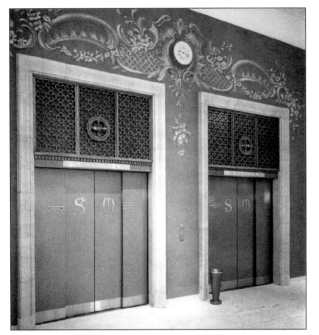

The store opened a colossal new building on the corner of Cleveland Avenue and Tuscarawas Street in 1925. Italian marble, walnut, rosewood, and mirrors created an elegant shopping experience that was unparalleled in Canton. The wide, spacious aisles were complimented by two elegant elevators with elaborately detailed bronze grillwork, pictured here. On opening day, customers raved about it in the pages of the *Repository*. One woman said, "Did you ever see so beautiful an elevator front?" (Photograph courtesy of Mr. and Mrs. Robert Mann.)

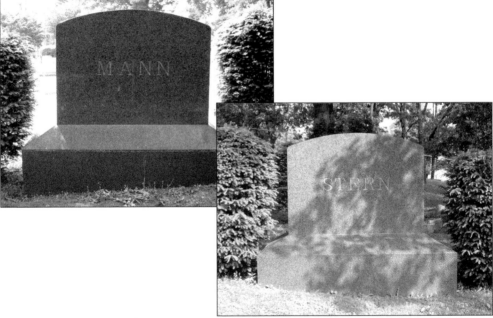

When they first opened, Stern & Mann sold mostly hats. They also stocked ribbons, buttons, fabric, and some dressmaking supplies. The clerks were stationed behind the counters and did not roam the floor helping customers. The store opened at 7 in the morning and stayed open until the last customer left at night, which was usually around 9 p.m. during the week. But on Saturday night, the store would be open until after midnight! Four generations of the family operated the store before the doors finally closed in the early 1990s. The two families were so close, they share a monument—it says "Stern" on one side and "Mann" on the other. (The monument is in Section X.)

Four
SOCIAL AND CIVIC LEADERS

Nothing makes a town more unique than the clubs, schools, and places of entertainment established by its residents. How people spend their leisure time says a lot about their society. Canton has been fortunate to have a plethora of interesting places to while away their spare time.

Over the years, many people have contributed to Canton's social scene. Some of the community organizations have included the Canton Cadets, the Chocolate Club, and the Aero Club, just to name a few. Members of many of these clubs have found eternal rest at West Lawn.

Civic leaders who worked tirelessly for better schools, a bigger courthouse, and an organization of agriculturalists can be found in West Lawn too.

Many of West Lawn's beautiful mausoleums are nestled into the hillside, overlooking the creek.

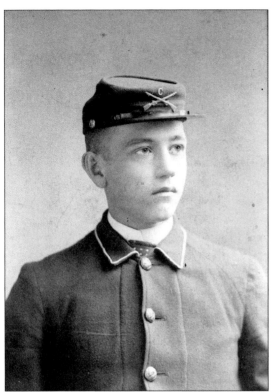

Harry E. Frease, dressed in his Canton Cadets uniform, was one of the young men who formed the voluntary military organization after the Civil War. A dozen boys aged 10 to 13 were impressed with the Decoration Day parade in 1876 and decided to form their own group. They marched with wooden guns, following strict military drilling protocols up and down the streets of Canton.

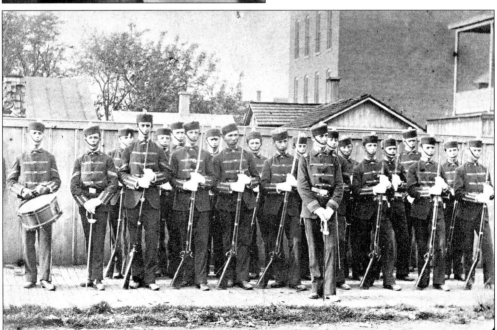

When they made their first appearance at a Memorial Day parade in 1877, John Danner noted in his scrapbook, "No single feature of the procession which marched to the cemetery yesterday was more attractive than the little cadets, whose trim, neat appearance and soldierly bearing were the admiration of all beholders."

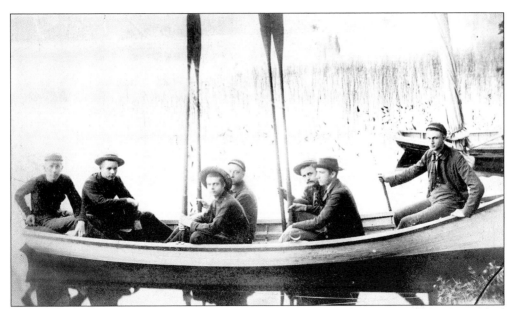

The Canton Cadets often camped out at Meyers Lake. They purchased the four-oared rowboat shown here after considerable saving of pennies. It was equipped with one sail so that it could be used as a cat boat.

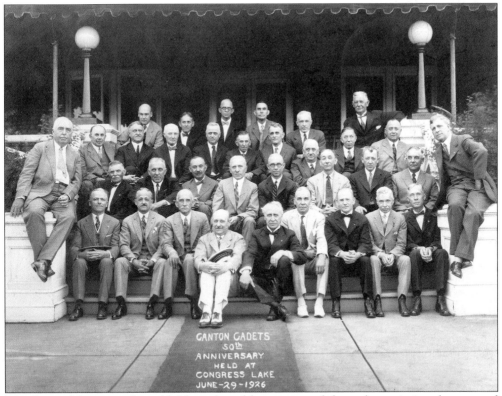

Members of the group forged lifelong friendships, inspired through patriotism, honor, and duty. Their 50th anniversary reunion, pictured here, was held in 1926 at Congress Lake.

(The Frease grave is located in Section F.)

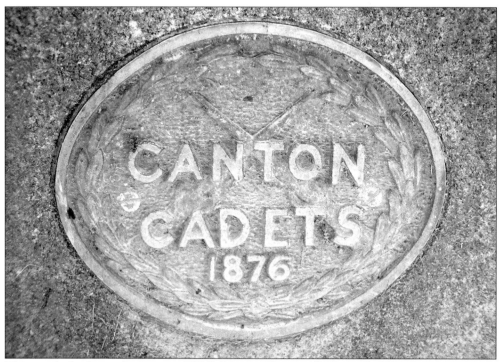

This symbol adorns the grave of Will Saxton. On a walk through West Lawn, one can still see markers identifying members of the Canton Cadets.

Louis Schaefer was one of Canton's most colorful and influential citizens. He was born in France and trained as a lawyer before immigrating to the United States in 1830. In February 1867, Schaefer announced plans to build an Opera House on West Tuscarawas Street. At the time, Comstock's in Columbus was the only opera house in Ohio.

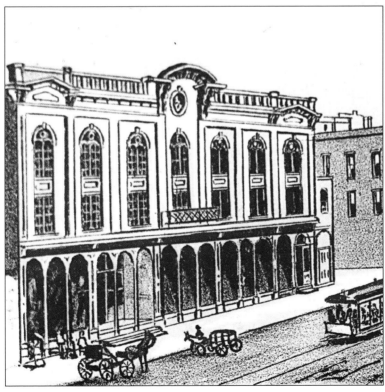

The town was deeply divided on whether Canton should have such an establishment in town. In general, the English-speaking churches were very much against it. The German-speaking churches, Catholics, and non-church goers were in favor of it. Plans proceeded, and 150 couples attended the Opera House's grand inaugural ball in February 1868.

Shaefer's Opera House

Manager, - - B. F. DUGAN. | Treasurer, - J. T. LESTER. | Scenic Artist, - M. WARD.
Stage Manager, Maj. H. LINDLEY | Prompter, FRANK BARRY. | Machinist, - L. DENHAM.

Last Night but Two!

EXTRAORDINARY ATTRACTION ! ! !

 The Great American Drama

With all its Original Effects, in 5 Acts, 12 Tableaux and 30 Scenes, from
Mrs. Harriet Beecher Stowe's Sublime Work of

Uncle Tom's CABIN

Or, Life Among the Lowly.

Being the same illustration of this truthful book which has been witnessed
by so many thousands throughout the largest cities of the Union,
and supported by the Press, the People and the Clergy.
This Moral and Religious Drama will be presented with a Powerful
Cast, Appropriate Scenery and Startling Effects.

Look at the Cast!

The Eminent Tragic Artiste,

MISS RACHEL DENVIL,

As ELIZA and CASSY. The Great Tragedian, Mr.

MORTIMER MURDOCH,

As GEORGE HARRIS, and by special permission of M. Canning, Esq.,
Pittsburg Opera House, the Child Wonder,

LA PETITE ELLA,

Only 6 years old, will appear as Eva, (as played by her 100 Nights at
Barnum's Museum.)

This (FRIDAY) Eve., Jan. 17th,

Will be performed the Great American Drama of

UNCLE TOM'S CABIN!

UNCLE TOM, the Faithful Slave............................Mr. FRANK BOSWORTH

Shaefer's Opera House hosted some "high class events," including *Hamlet*, *The Merchant of Venice*, and *Uncle Tom's Cabin*. He also showed some more popular shows like *The Streets of New York*, *Ten Nights in a Bar Room*, and *Rip Van Winkle*. Tickets sold for 25 to 50¢ a piece. Shaefer had many ties with the entertainment business, which brought many well-known actors of the period to Canton, when they passed over other towns of similar size.

This piece of letterhead, possibly in Schaefer's own handwriting, shows the amount paid to the stage hand and janitor in March 1890. Schaefer was always one to do as he pleased, regardless of public sentiment. He once brought Robert G. Ingersoll to Canton to give an atheistic lecture, which he purposely scheduled for a Sunday night. He

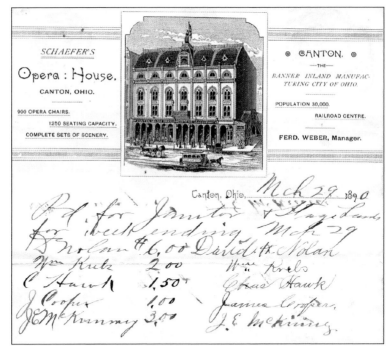

even hired a band to play outside to attract more people, some of whom were headed to evening church services!

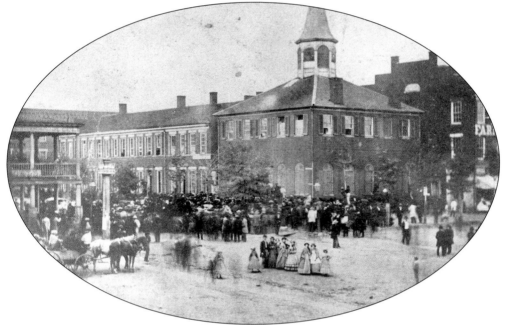

Despite his penchant for having fun, Schaefer was also very active in the civic affairs of Canton. After a number of buildings burned down because the fire trucks did not have an adequate water supply to drawn from, he helped establish a city water system. Schaefer also led the movement to build a new, larger courthouse. The city had outgrown the old one, pictured here in 1864.

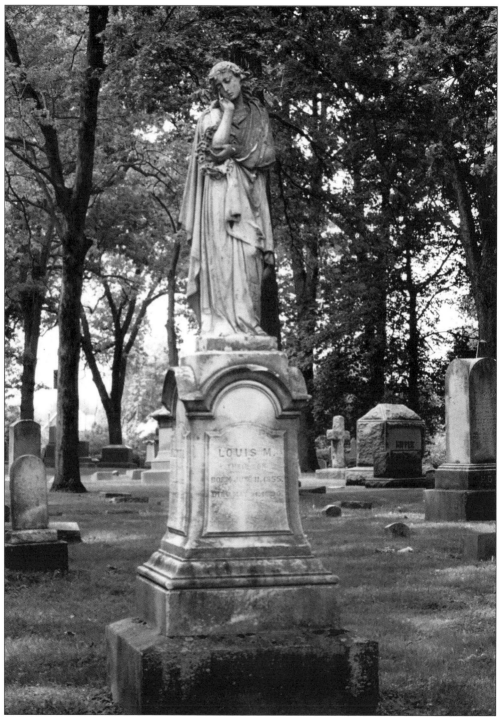

When Louis Schaefer died in 1889, so did his Opera House. He had been the heart and soul of the place, and it simply could not survive without him. His memorial, with the graceful angel statue on the cover of this book, is one of the most beautiful in West Lawn. (The Schafer grave is in Section F.)

John Lehman began as a teacher in Canton's public schools and rose to the position of superintendent when he was only 30 years old. He also operated an insurance company for 34 years.

Lehman High School was named for him in 1922 for his tireless efforts to improve Canton's education system. He was still alive at the time of the dedication, which is usually not the case when such an honor is bestowed.

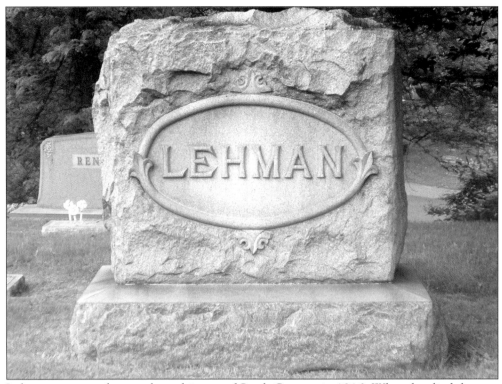

Lehman wrote a three-volume history of Stark County in 1916. When he died, he was 78 years old. (Lehman's plot is found in Section O.)

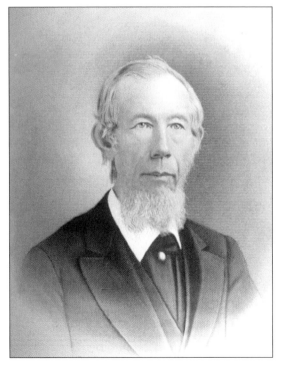

Madison Raynolds was one of the founders of the Stark County Agricultural Society. He owned one of Canton's early stores, and he would travel to New York City by horseback or stagecoach to purchase goods. In those days, the trip took 15 to 20 days!

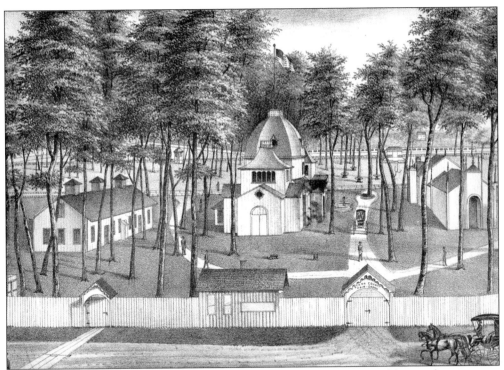

When the first Stark County Fair was held in October 1850, Raynolds was the secretary of the committee that handled all the details. That first fair was held in a field off of Market Avenue. This drawing shows the Stark County Fairgrounds as it looked in 1875.

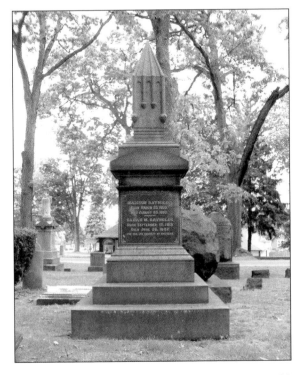

Raynolds died in 1883. (His grave is located in Section F.)

Zebulon Davis was one of the charter members of the Aero Club, a hot air balloon group organized by Frank S. Lahm in 1907. Lahm invited several prominent businessmen, including Davis, H.H. Timken, and Marshall Barber, among others, to dinner at the McKinley Hotel. When they were finished eating, Lahm invited them to form the Aero Club.

At the time, the idea of flight was a novelty and was certainly an exciting opportunity for the people of Canton. The Club raised $1,000 to buy their first balloon, which they named "The Ohio." When it was not in use, it was deflated and stored in the basement of the Courtland Hotel. Other balloons that flew out of Canton included "The Sky Pilot," "The Buckeye," "Cleveland," "All America," and "You and I."

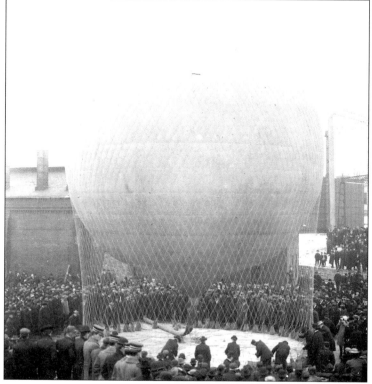

Pilots steered the balloons from the basket by using ballast. They were always trying to make flights as long as possible, both in distance and in time. Passengers also rode in the basket, under the large bag inflated with gas. The first flight took place on September 20, 1907, from Walnut Street.

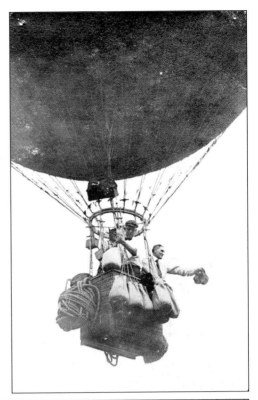

(Zebulon Davis' grave is in Section N.)

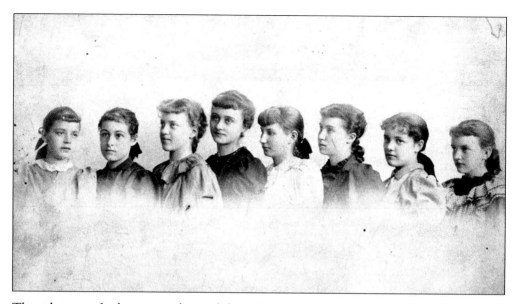

This photograph shows members of the Chocolate Club in the 1890s. This group of young women reigned supreme in Canton's social world. With the boys' club, Junior Assembly, they held elaborate summer dances and picnics at Meyer's Lake and winter parties at Bast's Hall. Dressmakers spent weeks making intricate gowns for Chocolate Club members. It is unclear why they chose the Chocolate Club as their name. It may have been associated with the elite reputation chocolate enjoyed in Europe. Pictured from left to right are Mary Barber Hartzell, Bessie Barr Kimbark, Louise Griffeth Parrett, Hattie Crum Clark, Jo Barnabay, Rae Frease Green, Alice Lynch Alexander, and Frances Lynch Miller. Besse Kimbark is buried in West Lawn. (Kimbark's grave is in Section O.)

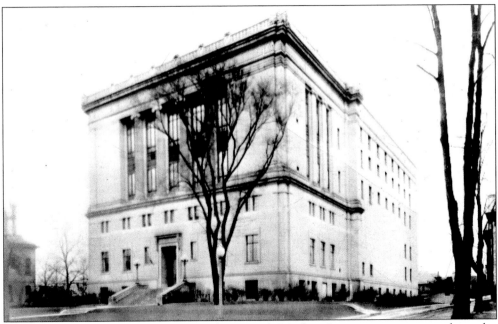

The present Masonic Temple, located on North Market Avenue, represents at least the sixth location Masons have gathered since the first lodge was chartered in 1825. Ground was broken for this building on June 28, 1924, and it was dedicated two years later. Several prominent men who are buried in West Lawn were Masons, including Louis Schaefer, George D. Harter, George Deuble, Charles A. Stolberg, George W. Belden, Cornelius Aultman, Arthur Turnbull, and William McKinley. (Photograph courtesy of Glenn Greenamyer.)

Many of the Masons buried in West Lawn have this symbol etched into their stones. Some do not. There is a small section in West Lawn dedicated to Masons, not far from the 7th Street entrance, and none of the stones bear this symbol. Eleven headstones and two urns honor the following: L.R. Hicks, Joseph Devlin, S.T. Keith, W.H. Burke, James W. Lathrop, Fred Orth, Edward Hyden, I.L. Chrisman, Frederick A. Reich, and Charles Silverman and his wife Louisa.

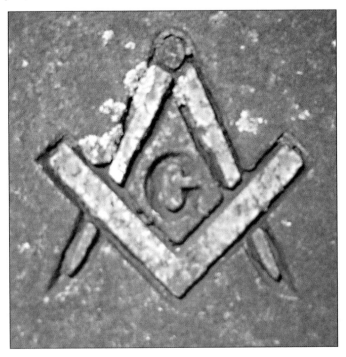

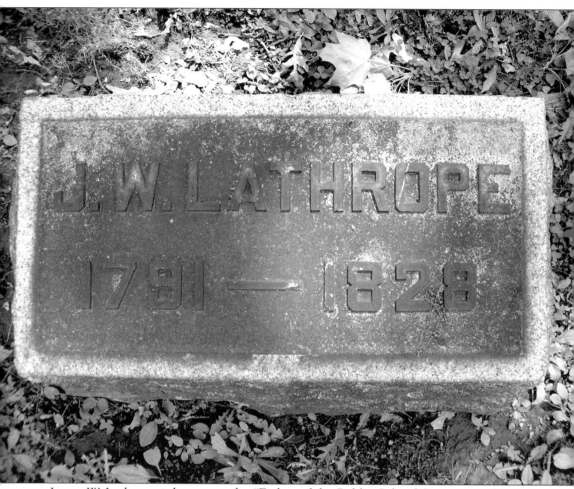

James W. Lathrope is known as the "Father of the Public School System in Ohio." He came to Canton when he was just 25 years old in 1816. He organized the town's first library and led the movement to establish Canton Academy. The two-story brick structure was finished in 1824, and 60 students were enrolled. The school was located on the plot of land Bezaleel Wells designated must always have a place of learning, where Timken Vocational High School now stands. Lathrope was a state legislator, where he chaired a committee to study the state's school system. He died in Columbus in 1828, and his body was moved to West Lawn in 1873. (The Lathrope plot can be found in Section F.)

Five
WILLIAM MCKINLEY

When William McKinley moved to Canton following the Civil War, the city would truly never be the same. His Front Porch Campaign was the biggest event that has ever happened in this city, attracting dignitaries from across the nation to a growing town in northeast Ohio.

Though McKinley was not born here, Canton claims him as the city's favorite son. He was a consummate public servant, who was elected congressman, governor, and finally president of the United States. Few communities in this nation can say they were home to a president, and Canton truly is proud to call itself a presidential town. Many of the president's family members and friends are buried in West Lawn. Indeed, the land where the McKinley National Memorial was built, now owned by the Wm. McKinley Presidential Library and Museum, was once part of the cemetery grounds.

After the president's funeral, West Lawn became the focus of the nation's mourning. McKinley was a beloved public figure whose life was tragically cut short before he could fulfill all of his potential. The mystique of deeds left undone haunts those who pass in the prime of life. Such is the case with William McKinley, 25th President of the United States.

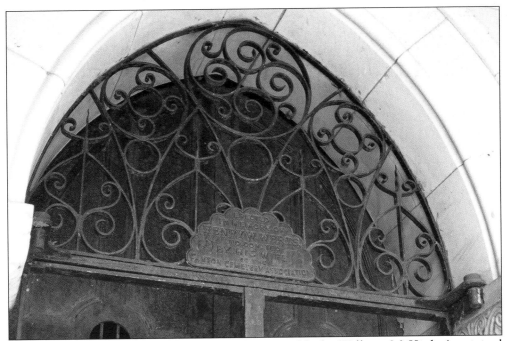

The arch over the door of the Werts Receiving Vault, William McKinley's original resting place, is decorated with intricate ornamental ironwork.

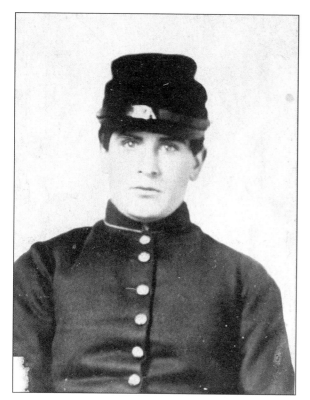

William McKinley was born in Niles, Ohio, in 1843. When the Civil War broke out in 1861, McKinley continued a family tradition of service and enlisted in Company E of the 23rd Ohio Volunteer Infantry. McKinley saw serious combat at the battles of South Mountain and Antietam, but was never injured. When he mustered out at the end of the war, he had earned the rank of Brevet Major. This photograph was taken shortly after he enlisted.

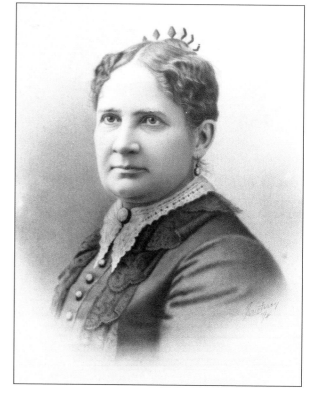

Anna McKinley was the first member of her family to relocate to Canton. Shortly after, her parents, brothers William and Abner, and sister Helen followed. Many believe McKinley High School is named after her more famous brother. But in truth, the school is named for Anna, who was a beloved teacher and principal in Canton for many years.

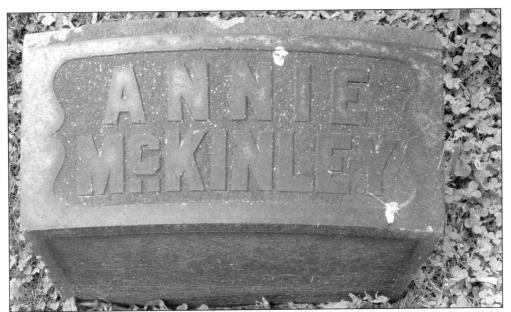

Anna McKinley died in 1890, just six years short of seeing her brother rise to the highest elected office in the land. Though she is commonly referred to as "Anna," her grave stone is inscribed "Annie." (She is buried in Section D.)

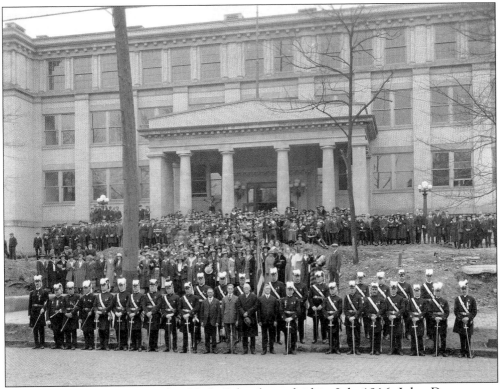

The cornerstone for McKinley High School was laid in July 1916. John Danner was present for the ceremony. Dedication ceremonies, shown above, were held in 1918.

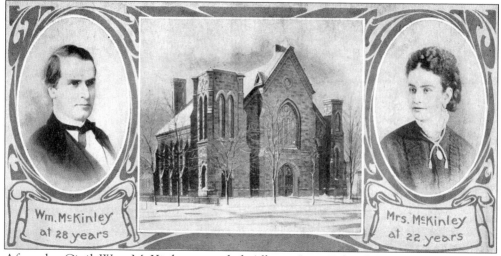

Wm. McKinley at 28 years

Mrs. McKinley at 22 years

After the Civil War, McKinley attended Albany Law School. His sister Anna was working as a teacher in Canton and encouraged him to move here and begin his career as a lawyer. Before long, he caught the eye of Ida Saxton, granddaughter of *Repository* founder John Saxton. They were married on January 25, 1871. It was the first event held in the new Presbyterian Church, which was not even completed. There were 750 guests, including Governor Rutherford B. Hayes, who would later become President.

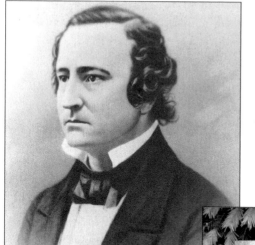

When McKinley came to Canton in 1867, he formed a law partnership with George W. Belden. From 1837 to 1843, Belden served as Common Pleas judge for the Fifth Judicial Circuit. From 1851 to 1855, he was elected District and Common Pleas judge of the Ninth Judicial Circuit. In 1857, President Buchanan appointed him United States district attorney for the northern district of Ohio.

GEORGE W. BELDEN 1810 — 1868

Belden died a year after forming Belden & McKinley on August 15, 1868. He was 58 years old. (Belden's grave is in Section F.)

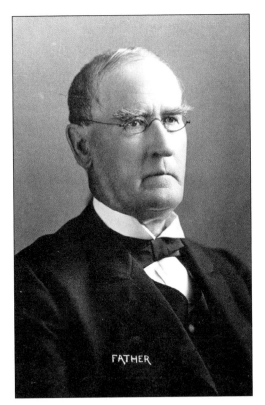

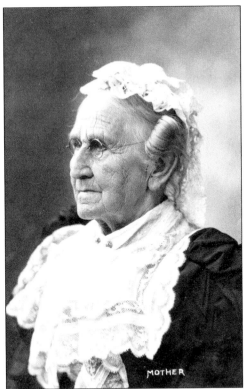

FATHER

MOTHER

William McKinley was the seventh of nine children born to Nancy Allison and William McKinley Sr., pictured here. The family's ancestors came from Scotland. When McKinley's father died in 1892, he dropped the "Jr." from his name. His mother lived to see her son elected 25th president of the United States. She died in 1897. (She was laid to rest in Section D.)

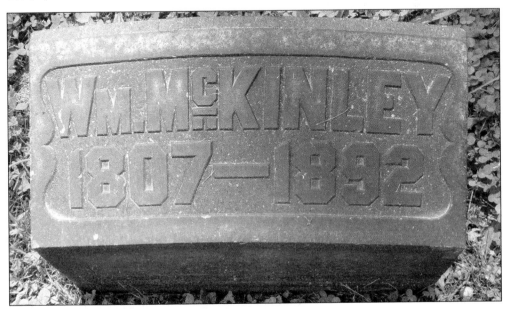

Ida's mother was Katherine DeWalt Saxton. She died in 1873, the same year the McKinleys' youngest daughter Ida passed away.

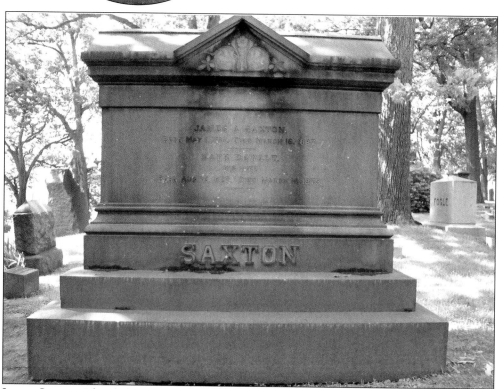

James Saxton, Ida's father, was born in May 1812 in the home on South Market Avenue where John Saxton originally printed *The Repository*. He ran a hardware store and also founded the Stark County Bank. He died in 1887. (Saxton's grave is in Section H.)

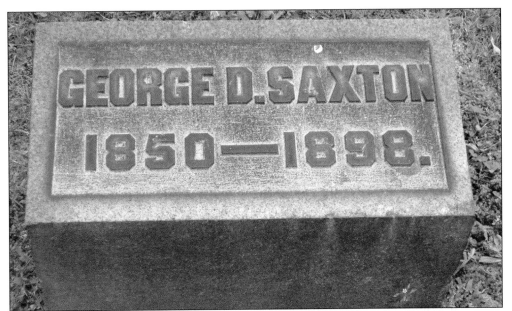

Ida's brother George Saxton had a reputation in Canton for being a "ladies man." His philandering led to his murder on October 7, 1898. McKinley was in the middle of his first term as president at the time, which must have caused him quite a bit of embarrassment. (George Saxton's grave site is also in Section H.)

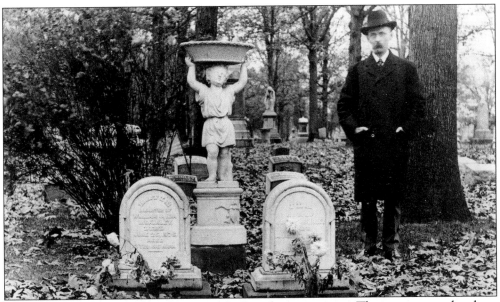

The McKinleys had two children soon after their marriage. Their youngest daughter Ida died in infancy in 1873. The older daughter Katie had heart trouble and died in 1875. After their deaths, Ida began to suffer from periods of severe depression, complicated by digestive problems, phlebitis, and fainting spells that were later diagnosed as epilepsy. This rare photograph shows the graves of both girls in West Lawn, before they were moved to the McKinley National Memorial in 1907. (Their daughters were formerly buried in Section D.)

My precious love.

I received your dear letter this morning & was delighted to hear from you, you don't say how you are. I went last night to the President's to dinner, Mr & Mrs Andrews were there & the latter sent you much love. Some of Mrs Hayes' relations were there, it was a good dinner & there were many inquiries about you. This is a bright, beautiful morning. I wish you were here, God bless & keep you. I get your letters regularly now, James expects to go to N.Y. tomorrow morning he sends love yours truly

Wm M Kinley

McKinley was elected to Congress in 1877. He was appointed to the Ways and Means Committee in 1880, the same year he wrote this letter to Ida. McKinley was deeply devoted to his wife and spent as much time as he could with her. When they were apart, he frequently wrote letters to her.

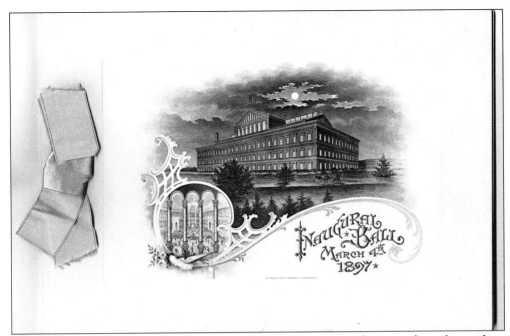

After serving as congressman and governor of Ohio, McKinley was elected president of the United States in 1896. A grand Inaugural Ball was held in Washington in his honor in March 1897. This commemorative program was given to each guest.

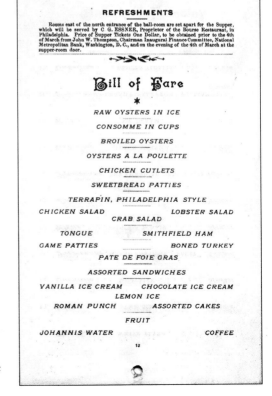

The bill of fare for the festivities included the finest culinary delights available in the Victorian era. The cost for dinner was $1 and included such delicacies as broiled oysters, pate de foie gras, lobster salad, and lemon ice.

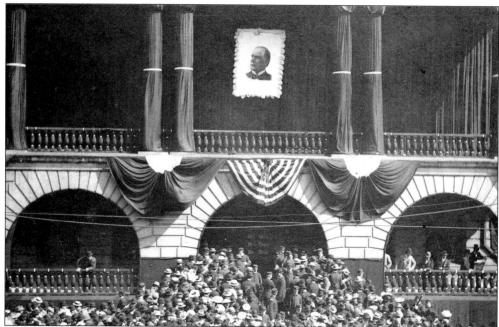

McKinley was re-elected in 1900, but sadly he would not serve a full year of his second term. While shaking hands at the Temple of Music at the Pan American Exposition in Buffalo, New York, he was shot at point blank range by anarchist Leon Czolgosz. At first his doctors thought he was going to be all right, but after almost a week of steady improvement, he took a sudden turn for the worst. He died on September 14, 1901. This photograph shows mourners lined up to view the body outside the courthouse in Canton.

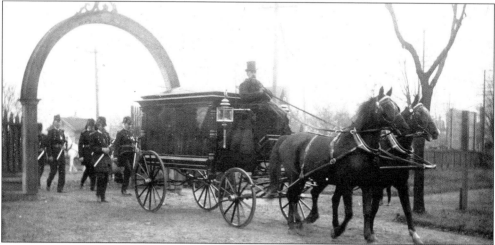

After services at the First Methodist Church, the McKinley funeral hearse entered West Lawn from present day 4th Street NW. His body was placed in the Werts Receiving Vault, which had been built in 1893. The Canton Cemetery Association hired the Central Ohio Stone Company to build the vault at a cost of $2,030, plus the cost of excavation, iron work, and all of the brick. The vault would provide temporary entombment in the winter months when frozen ground prevented burials. After its completion, Mrs. Frank M. Werts offered $3,000 to pay for it in memory of her husband.

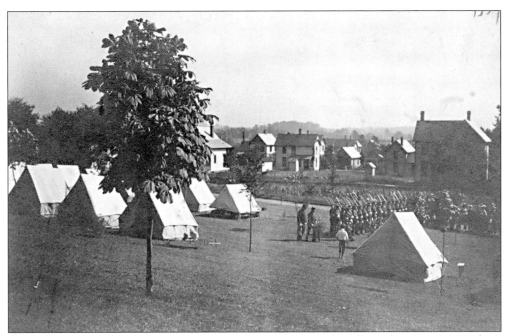

An encampment of soldiers grew up on the cemetery grounds at the time McKinley's body was placed in the vault.

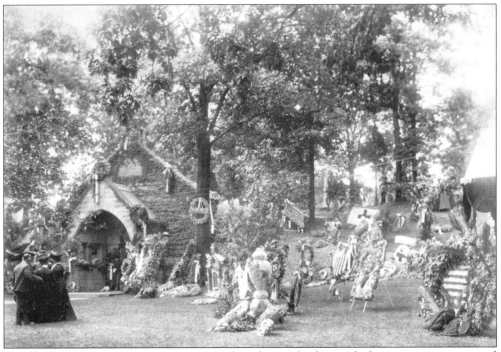

Hundreds of floral arrangements were placed outside the vault from organizations and individuals from around the world. Beautiful memorials were sent to Ida from every corner of the globe, many of which are preserved today in the collection of the Wm. McKinley Presidential Library and Museum.

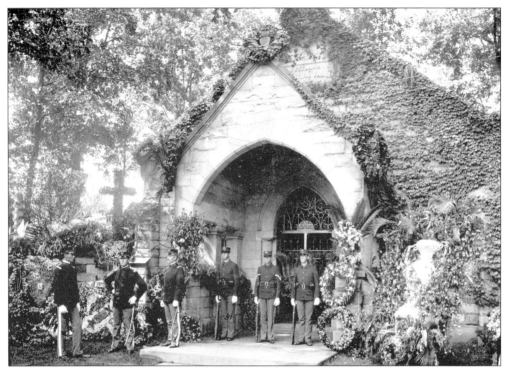

An honor guard was posted at the entrance of the vault and stood watch 24 hours a day for the six years the president's body was inside. Ida visited the vault daily until her own death in May 1907.

Immediately following the funeral services, the McKinley National Memorial Association formed to plan a suitable memorial to the slain president. They chose a spot on a hill adjacent to West Lawn that McKinley himself had often remarked would make a wonderful place for a memorial to Stark County's soldiers and sailors. They acquired 26 acres from the Cemetery Association and set out to raise the necessary funds. Construction began in 1905.

From the air, the monument's overall design combines the cross of a martyred president with the sword of the commander-in-chief during a time of war. The monument itself sits at the center of the cross, and forms the handle of the sword. The reflecting pool known as the Long Water, which was removed in the 1950s and replaced with a grassy basin, forms the blade of the sword. This photo shows the monument near completion.

The monument was finally dedicated on September 30, 1907. Sadly, Mrs. McKinley died that May and was laid to rest beside her husband in the Werts Receiving Vault. President Roosevelt gave the keynote address at the dedication ceremony. There were seats for 3,000 along the steps of the memorial, with some seats reserved for the 23rd OVI, McKinley's Civil War regiment. What most people did not know at the time was the bodies had not yet been placed in the monument. William, Ida, Katie, and Ida McKinley were moved from West Lawn to their final resting place in October 1907.

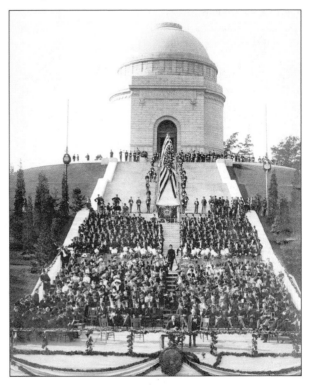

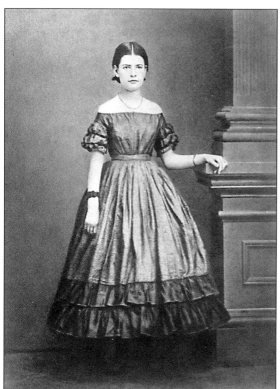

Ida's sister Mary, known to her family as "Pina," was a lifelong resident of Canton. The two young ladies went on a "Grand Tour" of Europe when they were still teenagers. Each wrote long letters home to their parents describing their trip, which have been transcribed and published in the book *Grand Tour* by Henry S. Belden III. Mary married Marshall Barber, who was the business manager of the Grand Opera House.

Mary helped to organize Canton's YWCA and was active in the Red Cross. She served as a trustee of the George D. Harter Bank, an unusual position for a woman at that time. When the president was shot, she rushed to her sister's side in Buffalo to comfort her. She died in 1917 at the age of 68. Mary named her only daughter, Ida Saxton Barber Day, after her sister. (Mary is buried in Section D.)

Six

POLITICIANS

Many local, state, and national politicians, including congressmen, judges, and mayors, left their mark on this world and are now laid to rest at West Lawn.

Their accomplishments in public life are numerous, but their personal lives are just as important for us to remember. Their stately homes, contributions in times of war, and personal integrity paint a picture of who these men were.

On a walk through West Lawn, some of their graves are clearly marked as public servants. Others bear only their names, with no trace of their impact on government and the lives of their fellow citizens. Some of them have been brought back to life here, through the records of historians.

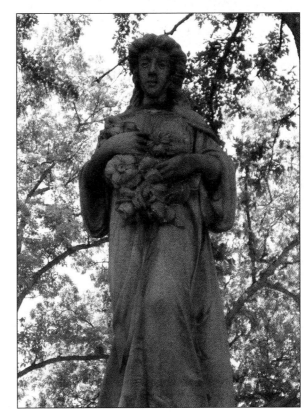

This graceful figure stands at the top of the Elben Monument.

Frank T. Bow was born on February 2, 1902. He attended public schools in Canton and Plain Township and went to the Ohio Northern University School of Law. During World War II, he was the news editor at WHBC and served as a war correspondent with the 37th Division in the Philippines in 1945. He was elected to congress in November 1950 and served 11 terms until his sudden death from a heart attack on November 13, 1972.

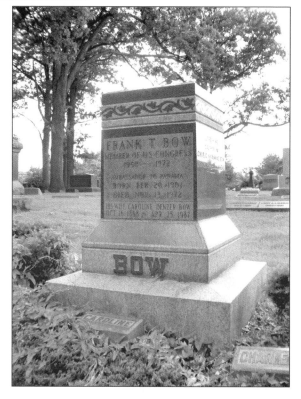

Shortly before his death, President Richard Nixon appointed him ambassador to Panama, a position he would have started in 1973. A statement from the president was read at his funeral service: "He was always a courageous spokesman for the truth...I was grateful when he consented to accept the post of ambassador to Panama. Now he will never fill that post...I have lost a valued friend." (Bow was laid to rest in Section N.)

(*left*) Atlee Pomerene came to Canton in the 1880s and became the law partner of Charles R. Miller, one of William McKinley's nephews. He was elected prosecuting attorney for Stark County in 1896, a position he held when Mrs. Anna George was accused of murdering George B. Saxton, Ida McKinley's brother.

(*right*) Pomerene married Mary Bockius in June 1892. She was a member of the Clio Club, a social group for society women that met twice a month for the purpose of education and camaraderie. The women took turns presenting programs and giving lectures to each other on a wide range of topics including: Family and Health, Winter Music, American Authors, Bees, Modern Meteorology, and the Socialist Party in France.

Pomerene became a US Senator in 1911. In February 1924, President Calvin Coolidge named him special counsel in charge of the litigation from a series of naval oil frauds, which became known as the "Teapot Dome" scandal. He died of pneumonia in 1937. The Stark County Bar Association and the Canton Lodge of Elks held special memorial services for him. (Pomerane's plot is located in Section 29.)

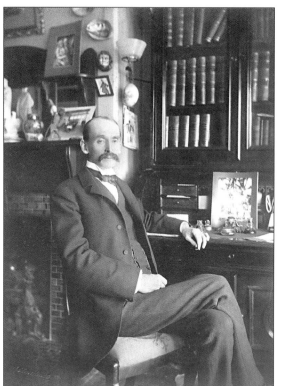

One of William McKinley's closest personal friends was William Rufus Day, a prominent Canton attorney who served as secretary of state. After McKinley's assassination, Day was a founding member of the McKinley National Memorial Association who organized plans for a suitable memorial to the slain president. Day was the master of ceremonies at McKinley's birthday celebration on January 27, 1903, where President Theodore Roosevelt addressed him as "Mr. Justice William Day"—an indication Roosevelt planned to nominate him for a seat on the Supreme Court.

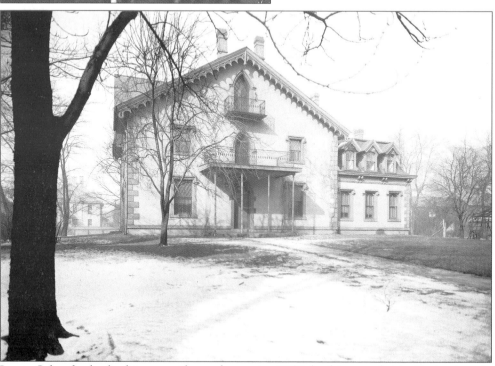

Louis Schaefer built this magnificent home in 1850 for his new bride Catherine A. Mealy. Day and his wife later moved into the house after they were married.

Day married Louis Schaefer's daughter Mary, a beautiful and charming lady. It has been said she inherited her father's sparkling wit and was a gracious and popular hostess in Washington D.C. circles when her husband became an important political figure.

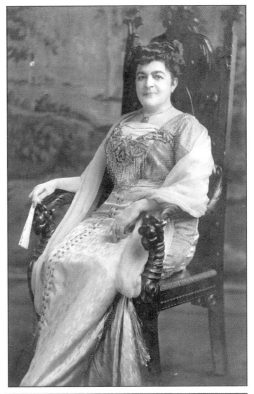

Day died at his summer home on Mackinac Island in 1912 after a long and illustrious career, serving both Canton and his country. (Day's grave site can be found in Section D.)

Charles Krichbaum graduated from Wooster College in 1883 and moved to Canton to become principal of the Plum Street School, which was located on the site of Wells School. He graduated from the Cincinnati School of Law in 1888 and formed a law partnership with Judge Henry W. Harter Sr. He served as Stark County prosecutor and as a probate judge. He was appointed to the Stark County Court of Common Pleas by Governor Cox in 1919 to succeed Judge Hubert J. Pontius.

The Krichbaums lived in this grand Victorian home, originally built by Canton's second mayor, Peter Chance. His wife Elizabeth "Lizzie" Gans studied voice under Cordelia McDowell of Canton. She went on to attend Hiram College and Oberlin Conservatory.

Judge Krichbaum was a recognized authority on the U.S. Constitution. He was a member of the Stark County Bar Association and the Elks Club. He was planning to run for reelection when he died of pneumonia in October 1930. (He is buried in Section 29.)

CITY HALL AND CENTRAL ENGINE HOUSE, CANTON, OHIO.

Many of Canton's mayors are buried in West Lawn. Most of them served in the old, stately City Hall pictured here. It was torn down in 1959 to make way for the present City Hall because it had become outdated and was much too small for the growing city's government. When the new building went up, historian E.T. Heald called it "startlingly modern" when compared to its predecessor.

Mayor Charles A. Stolberg resigned his position in 1917 to join the military with his son during World War I. His son died as a result of being gassed and injured on the front, a blow from which Stolberg never fully recovered. Throughout his life, Stolberg worked for the Aultman Company, Diebold Safe & Lock, and the YMCA. He was also a 32nd degree Mason.

Stolberg died suddenly of a cerebral hemorrhage, known as apoplexy at the time. Shortly after retiring to his second floor den, his wife heard a loud noise. When she called up to him, there was no answer. By the time she got upstairs, he was already dead. Stolberg received full military honors when he was laid to rest. He was just 55 years old. (Stolberg's plot is in Section Z.)

Arthur R. Turnbull was the mayor of Canton in September 1907 when the McKinley National Memorial was dedicated. President Theodore Roosevelt came to town for the festivities. Roosevelt, Governor Cox, and Turnbull are shown here at the reviewing stand at Public Square for the dedication parade.

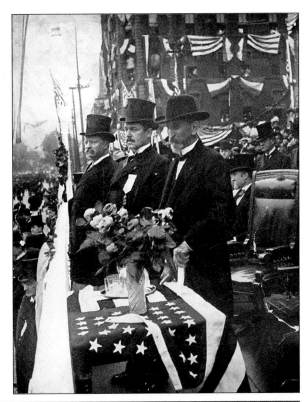

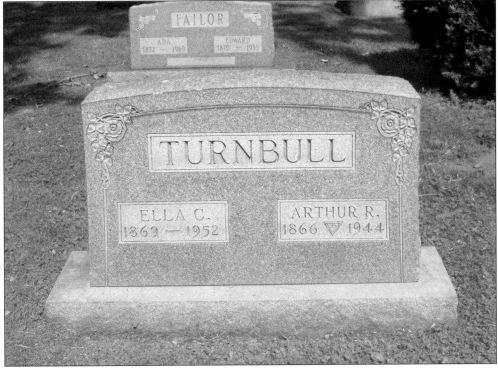

Turnbull served as mayor from 1906 to 1914. (Turnbull is buried in Section T.)

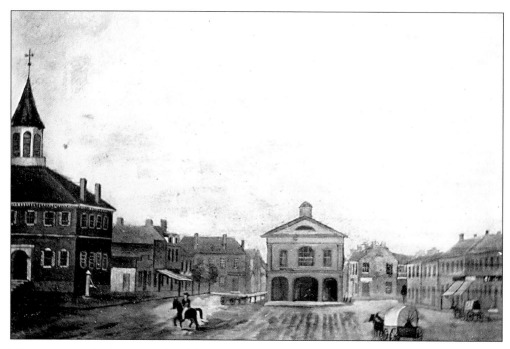

This is an early drawing of Public Square around the time F.A. Schneider served as Canton's president in 1836. The term mayor was not used until 1838. (His grave site is in Section F.)

Seven
VETERANS

Like many cemeteries, West Lawn is the final resting place for many veterans who served in our nation's wars. There are countless men and women who bravely served their country, but only a few are selected here to highlight Canton's citizens who marched off to fight in every war from the Revolution through Vietnam.

Each Memorial Day, Canton's Girl Scout and Boy Scout troops mark every veteran's grave with an American flag. It is a fitting tribute for the city's youth to pay respect to those who died, so we all can enjoy the freedoms we have today.

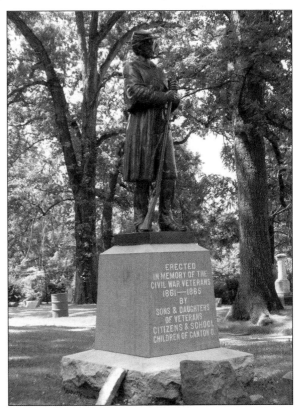

This smaller Civil War Monument is located in Section C. It was built by the "Sons & Daughters of Veterans" and the"Citizens & School Children of Canton O."

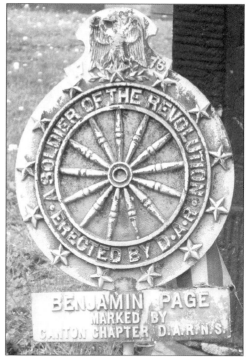

Captain Benjamin Page was an officer in the Revolutionary War, first serving with the Connecticut militia and later with the Navy. Capt. Page moved to Canton to be closer to his son. He is one of four Revolutionary War veterans in West Lawn whose graves have been recognized by the Daughters of the American Revolution. James Gaff, Zebulon Whipple, and Jacob Reed have also been identified. A fifth veteran, John Elliot, is believed to be buried in West Lawn, but no marker has been found for him. (Page's grave can be found in Section G.)

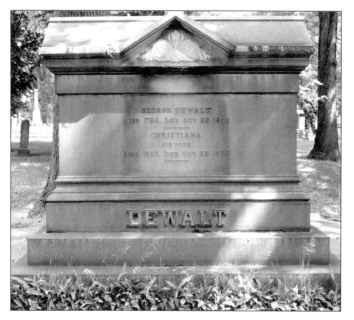

George DeWalt was Ida McKinley's maternal grandfather. His father Philip DeWalt started the Spread Eagle Tavern. When George took over, he changed its name to the Eagle Hotel. Meals were 25¢, and lodging for regular borders cost $2.50 per week. George DeWalt served in the War of 1812, as did Ida's other grandfather and *Repository* founder John Saxton. The back of this stone is the Saxton family monument. (DeWalt's grave site is located in Section H.)

Samuel Lahm was an Ohio senator and congressman. His son was aviation pioneer Frank Lahm, who organized the Aero Club of Canton. While spending time in Washington D.C., Lahm became impressed with the architectural beauty of the White House and decided to build his home on West Tuscarawas Street to resemble it. Lahm was a Mexican War veteran. (He was laid to rest in Section B.)

Jas. F. Willetts served in Company F of the 6th Calvary. His grave is located with several other larger Civil War veterans at the base of the statue. (It can be found in Section V.)

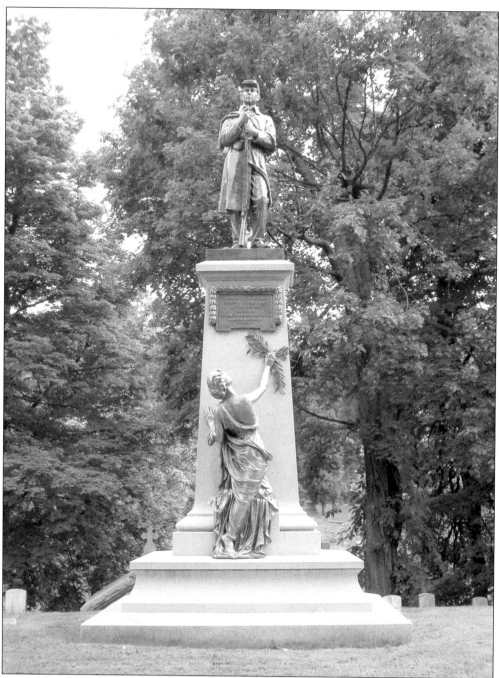

West Lawn is the home of a dramatic and poignant monument to all the soldiers and sailors in Stark County who served in the Civil War. In 1903, the local chapter of the national Civil War veterans organization called the Grand Army of the Republic (GAR) purchased a group of lots for a "soldier's burial place." The statue erected on that site features a gallant Union soldier watching over his comrades with an angel climbing up the pedestal toward him. It is one of the most striking and moving memorials in the entire cemetery. (This monument can be found in Section V.)

JOHN L. WHIPPLE
QM SGT 8 OHIO INF
SP AM WAR
JAN 29 1869 AUG 27 1946

John L. Whipple fought in the Spanish-American War, William McKinley's first major presidential crisis. The United States became involved in the bloody civil war between Cuba and Spain when the USS Maine exploded in Havana Harbor. The war took just 113 days and completely destroyed the Spanish fleets in Cuba and the Philippines. The United States emerged as a world power, with imperialist problems. As a result of the war, McKinley signed the annexation of Hawaii on July 7, 1898, and Guam became a possession of the United States. The United States was now in uncharted waters as an emerging world power, which would shape foreign policy for the 20th century and beyond. (Whipple's grave is in Section I.)

EARL E OVERCASHER
OHIO
PVT 158 DEPOT BRIG
WORLD WAR I
MARCH 25 1895 SEPT 4 1947

Earl E. Overcasher served as a private in World War I. (His grave is in Section W.)

BRUCE H BENNETT SR
PFC US ARMY
WORLD WAR II
MAR 22 1922 NOV 2 1978

Bruce H. Bennett Sr. served in the Army during World War II. (Bennett's grave is in Section 32.)

JAMES H PATTERSON
AIC US AIR FORCE
KOREA
APR 3 1932 JAN 20 1983

James H. Patterson served in the Air Force during the Korean War. (The marker can be found in Section 32.)

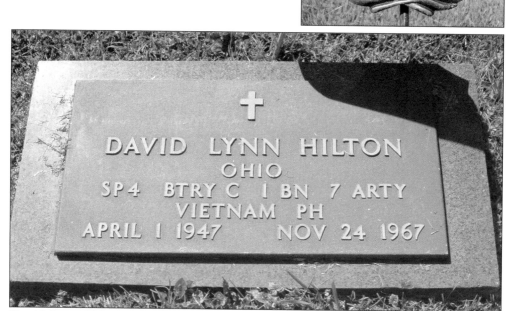

DAVID LYNN HILTON
OHIO
SP 4 BTRY C 1 BN 7 ARTY
VIETNAM PH
APRIL 1 1947 NOV 24 1967

David Lynn Hilton served in Vietnam. He was only 20 years old when he died. (Hilton's grave site is in Section 33.)

Eight
OTHER NOTABLE CITIZENS

There are some found in West Lawn whose contributions in life did not fit neatly into a defined category, but their contributions to Canton should not go unnoticed, as they had an impact on the community and had a hand in making the City of Canton what it is today. Their unique stories are just as important to tell, so this section was created to pay tribute to these interesting people, including a pioneer in flight, a quirky inventor, a pastor, and two doctors.

This square urn of purple flowers decorates the grave of Robert Little.

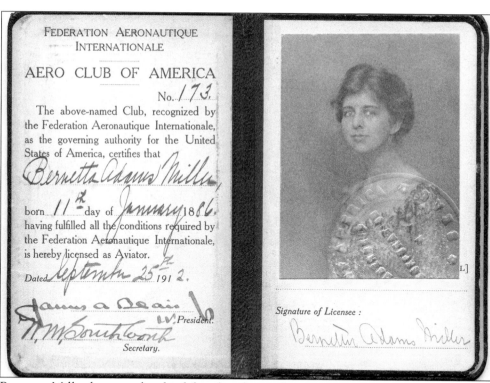

Bernetta Miller became the third female pilot in the country in 1912 when she earned her aviation license. She had saved money from her $5 a week salary as a bookkeeper to pay for her flying lessons. This is her pilot's license, issued by the Aero Club of America.

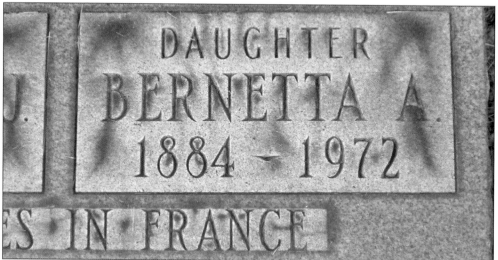

Miller considered her demonstration of the monoplane for the U.S. government the most important thing she ever did in her career. She worked on the front lines in France during World War I and earned the highest French award for her bravery. She died in 1972 at the age of 88. Her family shares a single stone, with a special notation that her brother "Sgt. Roscoe Conklin Miller 1879–1919 lies in France." (The Miller family plot is in Section O.)

Civil War soldier John McTammany began tinkering with an old music box while recovering from a serious injury he sustained in battle at Chattanooga, Tennessee. He later said it was while fiddling with the inner workings of the music box that he came up with the idea for the player piano. Between 1866 and 1877, McTammany made three models of his new invention. Other inventors disputed his original idea, but McTammany eventually won his case and received a patent in 1881. He died in 1915 at the age of 70. (His grave can be found in Section V.)

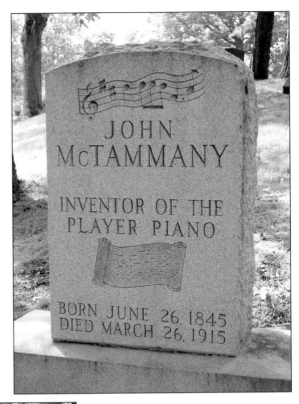

Rev. Ebeneezer Buckingham was the pastor of the First Presbyterian Church when the new building was built from 1868 to 1871. He officiated at William McKinley's marriage to Ida Saxton, the first major event held in the new church. In December 1859, Rev. Daniel Garver wrote a long editorial in the newspaper proving that Jesus Christ was born on December 25. The following week, Rev. Buckingham had an article just as long, proving he was not! (Buckingham's grave site is located in Section F.)

119

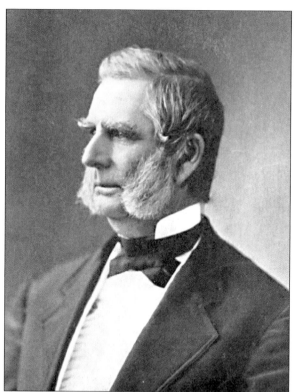

Dr. Lorenzo Whiting came to Canton in 1836 when the town's population was only 1500. He was a learned man who kept impressive company. He counted Ralph Waldo Emerson and Horace Greeley among his friends.

Dr. Whiting was instrumental in forming the Anti-Slavery Society, who met regularly in Canton's town hall. He was also an active "conductor" on the Underground Railroad. He died in 1884. (Whiting was laid to rest in Section G.)

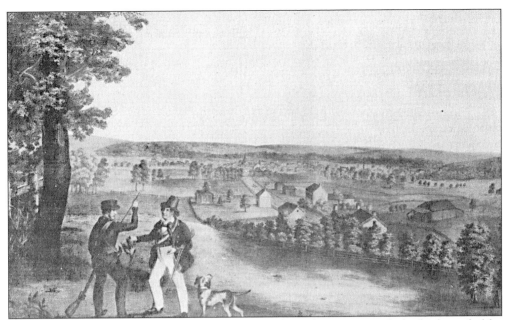

Dr. Andrew Rappé came to Canton in 1808 when the countryside looked much like this artist's conception of the area. He was born in Paris in 1779 and studied medicine at Frankfurt-on-the-Rhine.

In the early days of settlement, it was quite an asset to have a doctor in town, since they were few and far between on the frontier. It is possible that the presence of a doctor actually encouraged some to move to Canton. In those days, there were no hospitals and very few drugs. Doctors still made house calls, traveling on dirt paths from home to home. Dr. Rappé died in 1842. (Rappé's plot is in Section O.)

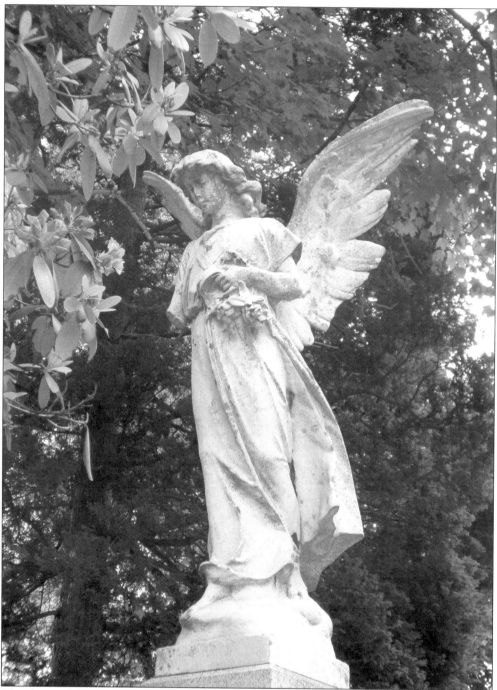

This beautiful angel marks the grave of the Paulus family.

Nine
BEAUTIFUL MONUMENTS

West Lawn contains some beautiful cemetery architecture, highlighted by unique designs and traditional themes. The examples shown here are meant to emphasize the beauty of West Lawn. There are hundreds of beautiful stones to see. These are some of the author's favorites.

These gorgeous monuments watch over people whose stories are difficult to trace. Some were not necessarily well known in the community, but they were all loved by their families and friends. Still, you may recognize a name or two.

Take a walk through the cemetery yourself sometime and pick out some of your favorites. Bring your camera along to capture the serenity West Lawn Cemetery can offer you.

When you start to listen to the whispers in the blowing leaves, when you open your eyes and look around you, the connection to the past is there. The figures of Canton's history are all around you, waiting for you to discover them.

This majestic figure watches over the McDowell Monument.

A gorgeous photograph of Inessa Khachaturov decorates her stone. This represents some of the more intricate details that can be added to gravestones today.

The Melbourne Mausoleum is one of the most spectacular at West Lawn. It is located along the oval drive where many of the other mausoleums sit, overlooking the creek.

The Vogelgesang Monument features an elaborate carving of a soldier. It is one of the more technically challenging designs in the cemetery.

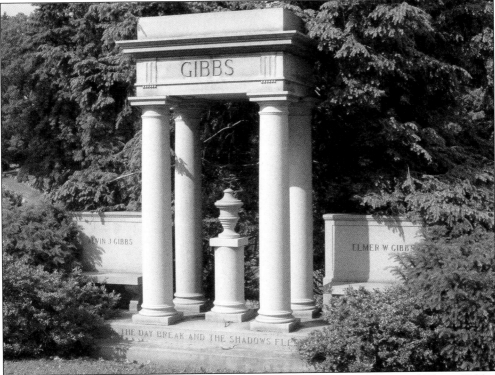

This spectacular monument is the final resting place of brothers Alvin and Elmer Gibbs, sons of Lewis Gibbs. The bottom reads: "Until the day break and the shadows flee away."

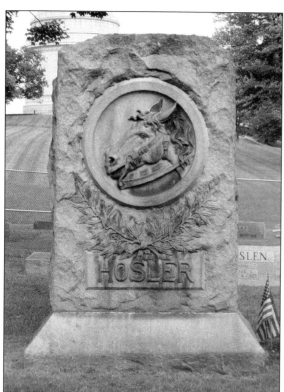

A horse adorns the Hosler Monument. The McKinley National Memorial is visible in the background.

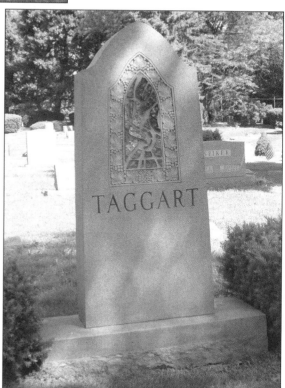

A striking stained glass window adorns the Taggart Monument.

126

A set of hands in prayer
embellishes the Jurebie Monument.

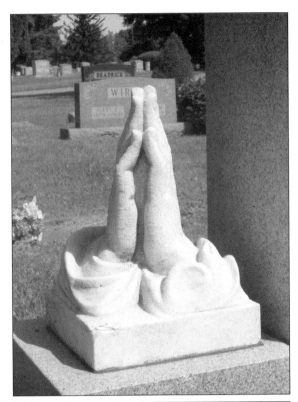

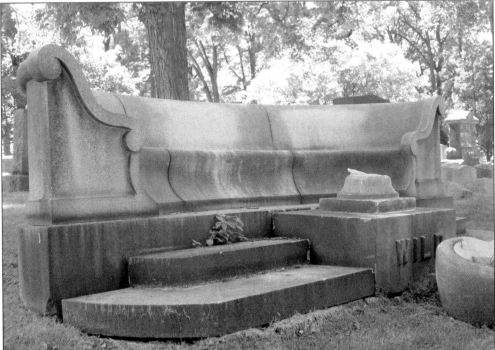

The unique Wild Monument steps up to a curved bench. Over time, the urn at the center has separated into two pieces.